BEGINNER'S GUIDES

PAINTING IN

Watercolour

JENNY RODWELL

STUDIO
VISTA

ACKNOWLEDGEMENTS

The author and publishers would like to thank the following artists
who have allowed us to use their work in this book: Sally Michel,
p. 74; Ian Sidaway, pp. 10-11, 12-13, 40-41, 74; Adrian Paschal
Smith, pp. 9, 10, 14-15, 41, 68-69, 74; Stan Smith, pp. 8-9, 11,
13, 15, 58-59. Special thanks are also due to Winsor & Newton for
technical advice and their generous help with materials; to Adrian
Paschal Smith for his step-by-step demonstrations and artwork; and
to Ian Howes for taking the photographs.

Studio Vista
an imprint of
Cassell
Villiers House
41/47 Strand
London WC2N 5JE

First published 1992

British Library Cataloguing in Publication Data

Rodwell, Jenny
 The beginner's guide to painting in watercolour
 I. Title
 751.422

ISBN 0-289-80056-0

Series editors Jenny Rodwell and Patricia Monahan
The moral rights of the author have been asserted

Series designer Edward Pitcher

Distributed in the United States by
Sterling Publishing Co. Inc.
387 Park Avenue South, New York, NY 10016-8810

Typeset by Litho Link Ltd., Welshpool, Powys, Wales
Printed in Great Britain by Bath Colourbooks

CONTENTS

The world of watercolour

WATERCOLOUR HAS tempted more people to try their hand at painting than almost any other medium. There is something infinitely attractive about the fresh, glowing colours of many watercolour paintings. They look light and effortless. They make you want to have a go. Watercolour painting can be as easy as it looks, provided you follow a few simple rules.

Watercolours often look splashy and spontaneous. They can give the impression that watercolour is an instant medium and that a picture need take only a few minutes to complete. This is usually far from the truth. Watercolour calls for patience and a systematic approach. Trying to do too much too quickly has led to more failed paintings than anything else.

The main difference between watercolour and all other paints is that watercolour is transparent. Try to think of a watercolour painting as a series of layers – one thin wash of colour over another. To a certain extent, the colour underneath will show through the one above, so that the picture is gradually built up. Even the loosest, most abstract watercolour still needs careful planning.

Transparency and versatility have been constant factors in the development of watercolour from the earliest times to the present day. Here the artist makes full use of these qualities when building up loose layers of shimmering colour in a flower painting.

ABOUT THIS BOOK

This book assumes no previous knowledge of watercolour painting. Its aim is to cover the absolute basics, from equipping yourself, choosing a subject and stretching a sheet of paper to mixing and applying the colours.

The basic techniques are explained simply and clearly in Chapters Four and Five. Follow these and you will avoid frustration and disappointments.

Demonstrations

As well as describing the principle techniques of watercolour, the book shows in photographed, step-by-step demonstrations how certain key techniques are used in an actual painting.

The demonstrations have been kept as straightforward as possible to show clearly how the painting develops. Captions describe what is happening at each stage. Although you may like to paint a similar picture, and learn by following literally the example set by the artist, it is envisaged that these step-by-step projects will also serve as a starting-off point, a practical inspiration for your own paintings.

What shall I paint?

Choosing a subject should present no real problem. Most people know what they find attractive and what sort of subject appeals to them most. The first advice is to keep it simple. Most of the subjects used by the artists in this book are either still-life arrangements or landscapes. Both these subjects are easily accessible and both can be painted in a straightforward and uncomplicated way.

Landscape is, and always has been, a particular favourite with watercolourists. The transparent colours lend themselves to the subtle effects of sunlight, transient clouds and the changing face of nature. As a subject, landscape often seems more daunting than it actually is, mainly because there are so many different elements to consider. That is why, in the final chapter of this book, the artist

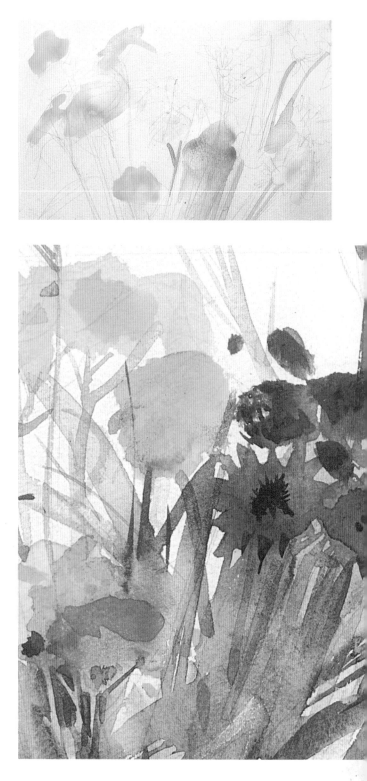

△ **Projects** *These are designed to take you step by step through the picture-making process. The first project is simple, showing how to start a painting with a coloured outline. Thereafter, each new project features one or two new techniques as well as techniques already covered. This detail of a flower painting shows how a painting develops and how it is photographed, stage by stage.*

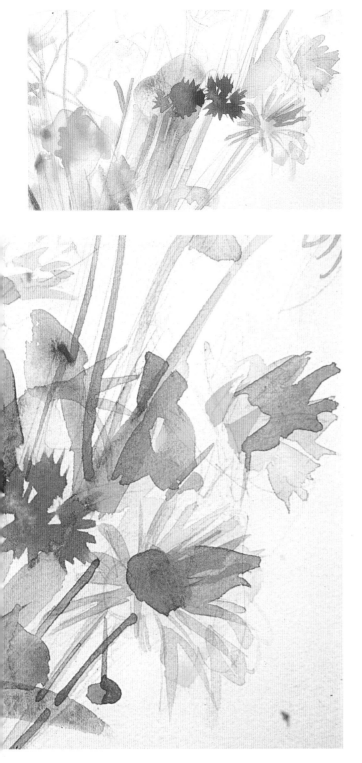

▽**Techniques** *Each watercolour technique is demonstrated and photographed in easy-to-follow stages. The technique pages are followed by projects in which the artist applies the technique to an actual painting. This sequence shows how to create a texture by painting over wax crayon.*

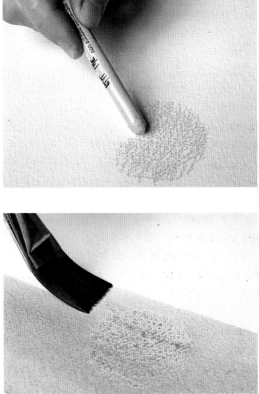

looks at some of these elements separately – skies, clouds, trees and water – and demonstrates in a clear, simple style some of the ways in which they can be painted and how they can be incorporated into a composition.

Figures and portraits have been deliberately omitted from the practical chapters of this book. This does not mean that you should avoid them altogether, but in the very early stages of learning to use watercolour, it is best to try out your techniques on subjects that are more readily accessible for longer periods and can be studied at leisure.

THE POSSIBILITIES

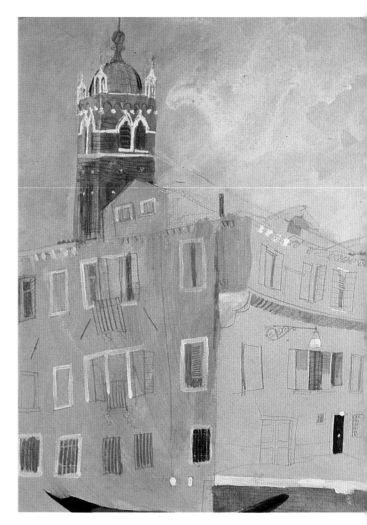

No painting medium has been more widely used, and in so many different fields, as watercolour. When the Stone Age cave artists painted animal pictures in their underground caverns more than 20,000 years ago they used ground pigments mixed with a binding medium not unlike the colours we use today. The ancient Egyptians employed a form of watercolour on their papyrus scrolls and later, in the Middle Ages, monks illuminated their biblical texts and manuscripts with vivid watercolour decorations, often embellished with gold leaf.

Since the eighteenth century, the history of professional watercolour painting has been closely linked with the history of landscape painting. On the occasions when it was used for figures and portraits, these were frequently done as preparatory colour sketches for a final picture, usually in oils.

Amateur painters have exploited the scope of watercolours as much as professionals. During the last 200 years, and particularly before cameras were generally available, a portable box of paints was an essential piece of equipment on family holidays, on the European Grand Tour and on voyages of discovery. Scientists and their assistants did on-the-spot watercolours of scientific specimens, especially the flora and fauna of newly explored lands; soldiers near the front line of battle often painted watercolour sketches of their surroundings to show family and friends back home.

Contemporary uses

Watercolour has never lost its appeal and its popularity has increased, first as a sketching medium and then soon afterwards as a medium in its own right. Today it is used in almost every field of the visual arts. Watercolour is popular with illustrators and graphic designers, not only for its intrinsic lightness and colour quality, but also because it reproduces well and always looks good on the printed page. Modern printing techniques capture exactly the effect of transparent colour over white paper and a quality reproduction is often virtually indistinguishable from the actual painting.

For the fine artist, the scope is enormous. Watercolour works well on any scale. On a large sheet of paper, using big brushes, you can paint as loosely and be as expressive as you like. Yet it is equally suitable for tiny pictures. Many miniaturists work in watercolour, painting with the finest of sable brushes and the help of a magnifying glass to capture the detail needed for such small-scale pieces.

Mixed media

Many early watercolourists used the medium on its own or, occasionally, with pen and ink. Most of them had a rather rigid attitude about the purity of watercolour and were particularly strict about not combining it with opaque paints such as gouache, which they felt detracted from the transparent quality of pure watercolour.

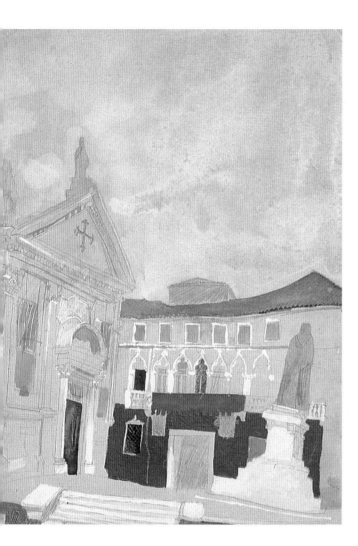

△**Mixed media** *This lively painting of Venice is done in watercolour, gouache and pencil on a tinted paper. The drawing is light and loose, and the artist has used the paper tone to represent the stonework of the building. Other selected areas are painted as flat shapes in gouache and watercolour.*

Today's painters are more experimental and, thankfully, have a less purist approach. They mix their media quite happily in a creative rather than a surreptitious way. When we see watercolour and gouache used together in the same painting it has usually been done deliberately in order to exploit the contrast between the transparency and opacity of the two paints, rather than as an apologetic touching-up.

The emphasis in this book is on the basic techniques of watercolour used on its own. However, it is worth remembering that you are working with an extremely sympathetic and versatile paint. It can be used with a number of other materials, including coloured pencils, dip pen and ink, and pastels, as well as the many technical and fibre-tipped drawing pens now on the market. So keep an open mind and do not be afraid to experiment.

▽**Abstract** *A royal burial site inspired this pair of paintings titled 'King and Queen'. Layers of paint, built up to create rich and colourful images, also symbolize the archaeological layers of the ancient grave. The subject – the figures and the artefacts buried alongside them – were used as a starting-point only. Thereafter, the artist was mainly concerned with the abstract qualities of the painting. The subjects themselves are barely discernible in the finished paintings.*

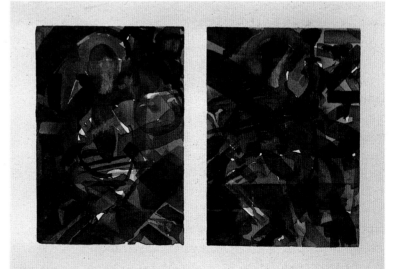

CHOOSING A SUBJECT

Start with a very simple subject. A few objects against an uncomplicated background make an ideal starting-point and will enable you to concentrate on the basics instead of having to worry too much about complicated colours, patterns and composition.

Initially, an arrangement of two or three vases or a limited selection of fruit will give you the opportunity to practise some of the basic watercolour techniques. Once these are mastered, you will move on to other, more ambitious subjects with greater confidence.

The secret of successful watercolour painting lies in simplicity. A practised artist can look at any subject and simplify it into essential areas of colour and tone, often portraying the most complicated subject with just a few strokes of paint. Detail is suggested rather than copied; at close quarters many watercolour paintings look like mere splodges of paint, the subject completely unrecognizable.

Be selective
But this ability to simplify a relatively complicated subject comes only with practice. For a newcomer to the medium, still learning how to use the paint, it is far better to begin with a simple subject. How to set about achieving a simplified representation of a complex subject is something that is learned gradually.

A good rule of thumb is to tackle a detail of what you can see rather than attempt the whole thing. For instance, when confronted by a rural landscape with hills, trees, stream, footpath and gate, don't attempt to include all of them in one painting. Be selective and choose, say, the gate, with a little surrounding foliage, or a few trees silhouetted against a wide expanse of sky. Similarly, avoid the temptation to paint a whole room or complex still life. Pick a fragment of the total composition and you will be surprised at how a straightforward subject can make an effective painting.

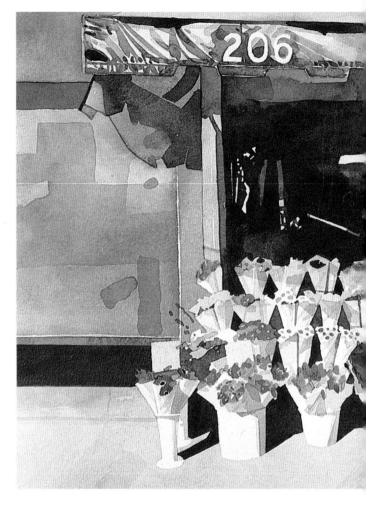

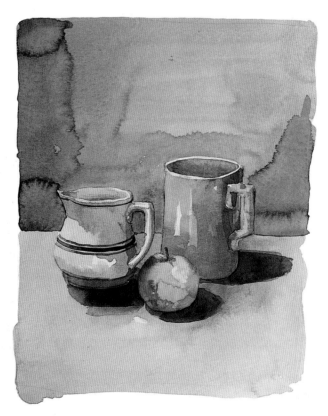

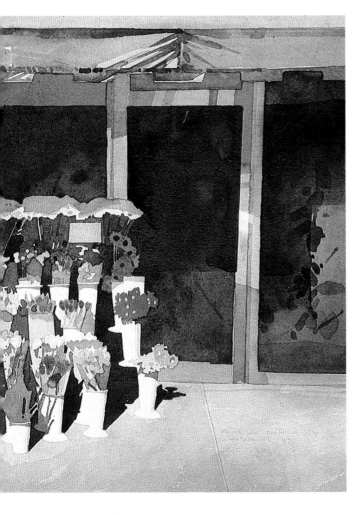

▽**Figure** *Movement is the essential element in this colour sketch. The woman is dressing and the artist must work quickly to capture the moment. The painting therefore has no outline, no preliminary drawing and no detail. Instead, the moving figure is simplified and expressed in washes of colour, applied directly to the paper.*

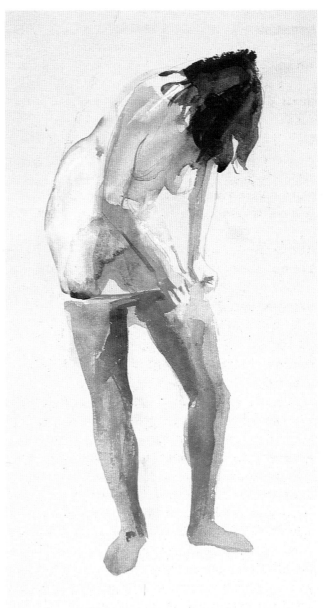

△**Urban landscape** *A scene which could well have intimidated an inexperienced artist has not daunted Ian Sidaway. Instead, he has successfully simplified the subject and painted it as a series of simple shapes and in a limited range of colours and tones. The flowers are depicted as bright blobs of colour; pavement, paper wrappings and vases are all left white; while other elements are painted in three tones of grey. The scene is further simplified by being painted 'head on' – in other words, there is no perspective, and the building and pavement run absolutely parallel to the bottom edge of the picture.*

◁**Still life** *A few objects against a simple background make an ideal 'starter' subject, enabling you to concentrate on the basics without the distraction of a complicated composition or confusing surface patterns. As you will see from this painting of a jug, apple and mug, a very ordinary subject can be painted in an interesting and animated way by applying colour freely, with broad, lively brushstrokes.*

11

SUBJECT TOPICS

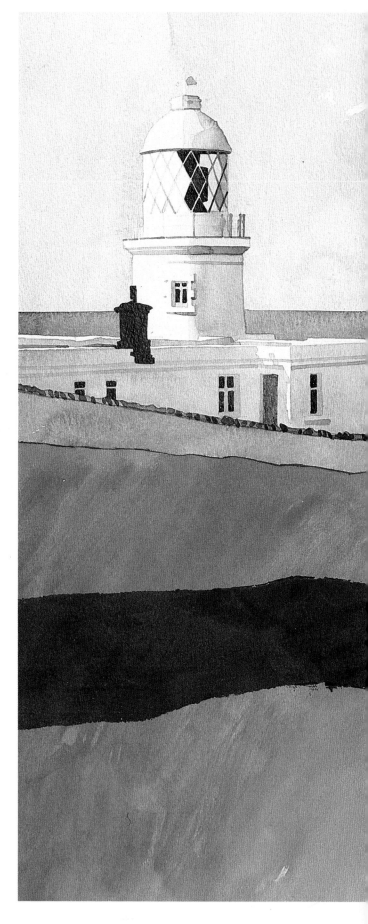

Practical considerations are often the deciding factor when it comes to choosing a subject. If the weather is good, it is tempting to work out of doors; if you have a willing sitter, this might seem a good opportunity to try your hand at a portrait or figure painting. Otherwise, flowers, plants and domestic objects are accessible and attractive possibilities.

Choice of subject is very personal, so pick something you like and find inspiring – even if this is not attractive in the conventional sense. For instance, many artists find urban and industrial landscapes more exciting than rural scenes. Others are more interested in mechanical objects. The choice is wide and infinitely varied.

Whatever you decide to paint, the approach is the same. Treat the subject exactly as you would if you were painting a single, simple object. In other words, start by looking at what is front of you and decide how it can be made less complex.

Light and weather
If you are working indoors, good lighting is essential, so make sure the light source is strong enough to enable you to work comfortably. Light changes rapidly, both with the weather and gradually throughout the day. Daylight bulbs are a good alternative to natural light – either as a replacement for it or to supplement fading light.

Painting outdoors can be stimulating and re-warding because the translucency of watercolour is ideal for capturing the effects of natural light and the bright colours of nature. Make sure you are well prepared when you set out on an outdoor painting trip. Weather is unpredictable, so take waterproof coverings for yourself and your painting. You should also be prepared for wind, so arm yourself with clips for fixing the paper to the board. Many artists find string and wooden pegs make useful guyropes for fixing the easel to the ground. For long painting sessions, you will also need a folding stool.

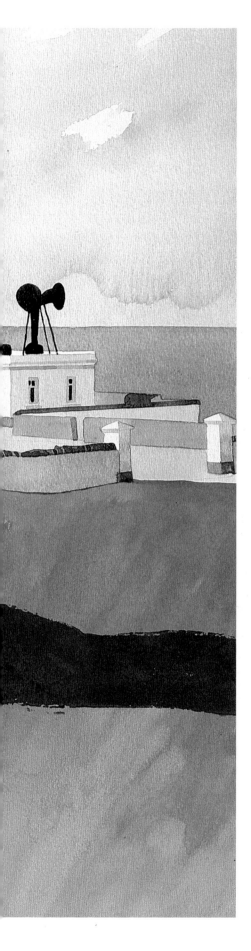

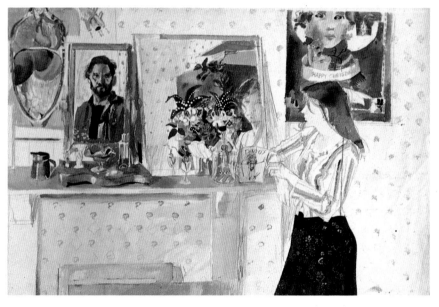

◁**Painting outdoors** *The weather was blustery and changeable when the artist, Ian Sidaway, decided to paint this seaside scene. He got round the problem by taking photographs of the subject, and then did the painting in his studio later. Simplified shapes and colours lend a strong graphic quality to the finished painting: the grass is painted in a single green, enlivened by coarse brushstrokes and a stark shadow; the lighthouse is depicted using white and two tones of grey.*

△**Figure painting** *The artist's wife is the model here; the background is the sitting-room mantelpiece. It is essentially a 'busy' painting, with lots of background pattern, ornamental shapes and other decorative elements. As with all figure painting, accurate observation is important. To accentuate some of the decorative elements, the artist, Stan Smith, uses splashes of bright, opaque gouache.*

SKETCHING AND DRAWING

Many people are put off painting in watercolour because they feel their drawing is not good enough. This is a pity, because drawing is a skill which can be learned and it has as much to do with observation and accuracy as with natural ability. Like all skills, drawing can be improved with practice. While it is true that a bad drawing will usually be reflected in the painting, it is also the case that the more painting and drawing you do, the more proficient you will become at both.

Sketchbooks

It is an excellent idea to carry a small sketchbook around with you and take every opportunity to make quick on-the-spot drawings of anything that catches your interest during the day. Busy people are rarely able to put time aside for sketching, but a pocket-sized sketchbook can be used in trains, waiting rooms, parks, cafés and many other places where you might happen to be and where there is lots going on. Apart from improving their drawing skills and powers of observation, many artists find their sketchbooks an invaluable source of reference and inspiration. They depend on them for ideas on what to paint and also for specific reference, such as what a particular type of tree looks like, or how different people sit, walk and stand.

Sketching also helps you to remember what you have seen. If you have to look at something closely enough to make a drawing of it, this commits the image to memory and often enables you to paint directly from memory afterwards.

Recording colour

Colour sketches are particularly useful if you are working outdoors and don't have time to finish the painting. You can make a very quick colour sketch of the subject and take this home to work from in the studio. It is surprising how much information can be contained in small, accurate colour sketches and how precisely they can show tone, colour and atmosphere. Some artists also take a camera when they go out painting, finding that the combination of a colour sketch and a photograph contains enough information to work from at home. Many places now process and print photos within the hour, so this method is particularly efficient. Strangely enough, a photograph on its own is rarely sufficient to work from because it usually flattens the subject and changes the colours and tones.

An artist's sketchbook frequently tell more about the painter than the finished paintings. Certainly, watercolour sketches have freshness and spontaneity that a more finished work often lacks. Many artists are well aware that their larger, completed paintings run the risk of looking stiff compared with the sketches they were painted from, and they take steps to avoid this. One way to re-create the freshness of the small sketch is to work quickly and to paint with a large brush.

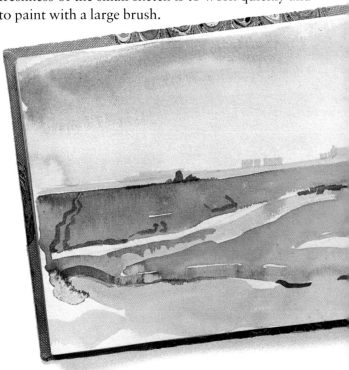

△**Colour sketch** *A sketchbook is a vital piece of equipment for Adrian Smith, who, like many artists, prefers to work either directly from the subject or from his own notes and sketches. This horizontal landscape took just a few minutes but it captured the colours and atmosphere of the scene and was the basis of many watercolours done later in the studio.*

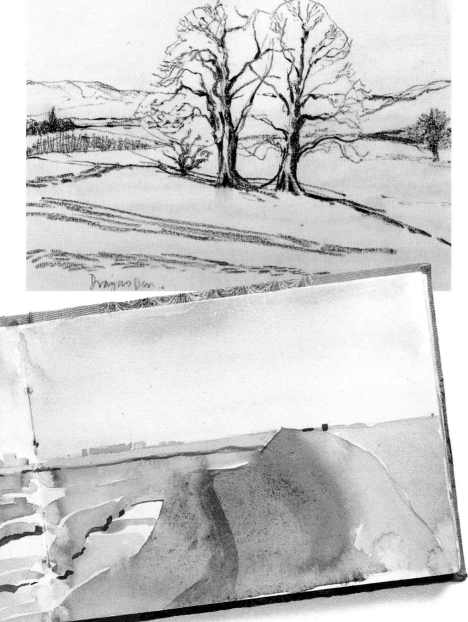

△**Winter landscape** *Skeletal shapes of trees in winter are sketched in black pencil. The drawing, which took just a few moments, is minimal but accurate. Like most of his sketches, the artist envisages using it as a reference for future paintings.*

▽**Figure in sunlight** *Light and shadow are inconsistent and this can be a problem when painting directly from the subject. This lively, bold pencil sketch captures a moment in time as the sunlight casts strong shadows and highlights across the woman's figure. The sketch was an important reference in a finished painting.*

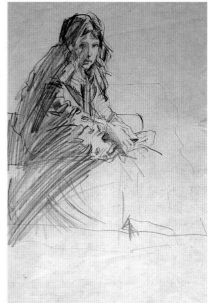

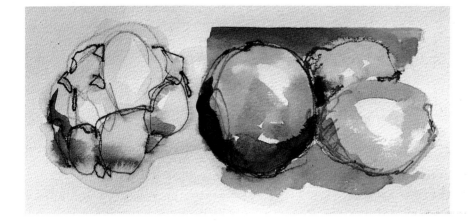

◁**Still life** *This rapid colour sketch was done in watercolour wash and crayon. Made prior to an actual painting, its purpose was to give the artist an opportunity to work out which colours and materials to use in the final picture.*

15

CHAPTER ② CHAPTER

Materials

CHOOSING THE RIGHT EQUIPMENT should be pure pleasure. There are so many excellent materials around that there is little chance of not being able to find what you want. It is really a question of getting advice on how to choose from such a vast selection, and of knowing what is essential.

The needs of the watercolour artist have changed little in hundreds of years. Now, as then, the basics are brushes, paints, paper and easel. The various media and additives can be introduced as you become better acquainted with the skills of watercolour painting.

The difference between us and our ancestors is that we have a wider choice of materials and can get hold of them far more easily. Early watercolourists had to grind and mix their own paints from a limited range of pigments; we simply walk into a shop and make our selection.

The following pages contain a guide to paints, brushes and other useful watercolour equipment. A good art shop will stock everything. With care, paints and brushes should last a long time, so buy quality materials from the start. Your initial outlay will be amply rewarded with many happy hours of painting.

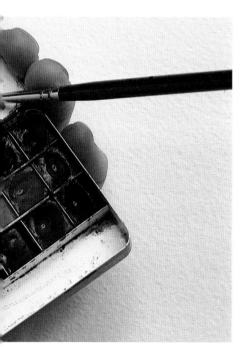

◁ *A paintbox that can be slipped into your pocket for painting and sketching trips is invaluable. Such boxes are available from art shops and contain artists'-quality paint in replaceable containers. The lid can be used as a palette.*

▽ *Watercolour papers vary in texture and weight. Here the artist demonstrates the effects of colour on seven different types. From left to right the papers are: handmade rag, technical, hot pressed, rough, watercolour board, 'not' hot pressed and cartridge.*

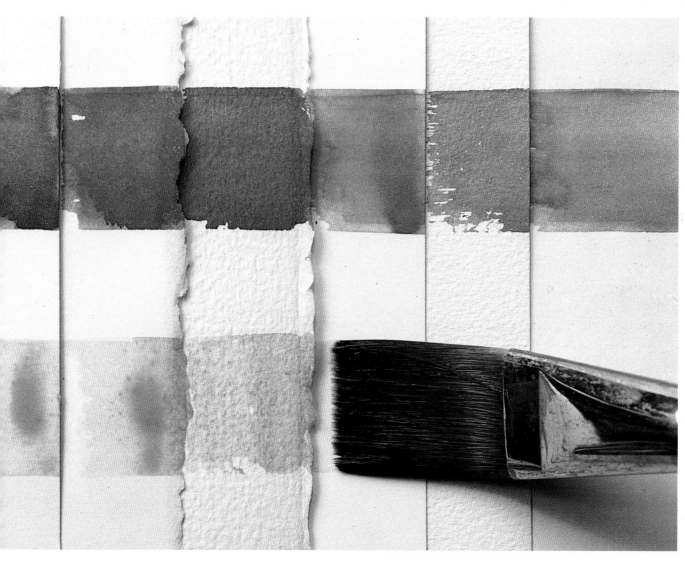

PAPERS

Watercolour papers – or supports, as they are often called – come in a range of surface textures from very rough to smooth, and the type you use will depend on the effect you want. A very rough texture has a pitted surface which often shows up as tiny white flecks in the paint. These flecks give the colour an attractive shimmering appearance, and are a characteristic of many watercolour paintings.

A landscape painted across some commonly used papers shows the difference between the surface textures: (from left to right)

Rough rag paper

Smooth papers produce a flatter effect and are usually chosen for more controlled, detailed work.

The very best papers are handmade from pure linen rag, and these have a noticeably irregular surface. Handmade papers are a delight to paint on, but they are expensive and this makes them impractical for the beginner who is still learning and experimenting with painting techniques. The majority of papers for general use are machine-made.

Hot, 'not' and rough

Three types of machine-made paper are available to the watercolour artist: hot-pressed, cold-pressed (sometimes called 'not' paper, because it has not been hot-pressed) and rough. The smoother papers are those which have been hot-pressed; cold-pressed paper are semi-rough; and rough, as the name suggests, have a very textured surface. Good watercolour papers are sealed on the painting side with size, which creates a good, receptive surface

Illustration card

for the wet colour. If you cannot tell the sized side by looking at it, look for the manufacturer's name – either embossed or watermarked – which reads correctly (the right way round) on the painting side of the paper.

For the beginner, a medium-textured, cold-pressed paper will probably produce the most immediately pleasing results, because the surface helps keep the painting alive and fresh. However, any textured paper takes a little getting used to and you will need to practise. For one thing, the brush must be well loaded with colour and applied with confidence, otherwise the painting will look dry and scratchy. Nor is it easy to get a flat wash on a very textured paper, so if you particularly want a flat background, choose one of the smoother hot-pressed papers.

Papers are graded by weight per ream (500 sheets). Thus a lightweight paper is around 40 lb (18 kg) and a very heavy paper is 400 lb (182 kg).

'Not'

Any paper weighing less than about 150 lbs (68 kg) will buckle and wrinkle when wet and must therefore be stretched before use (see overleaf); otherwise you can normally work directly on to the support. When you buy watercolour papers in art shops, the name and weight of the sheet is always given.

Blocks of paper
Watercolour paper is also available in blocks. The sheets are gummed together at their top edges and a painting can be completed, then lifted off. The sheets are mounted on stiff cardboard backing and are thus particularly useful for working outdoors, because they can be used without a drawing board.

Cheap cartridge papers and other drawing papers are not a good idea. Apart from buckling badly when wet, the surfaces tend to disintegrate as you work – obviously a disheartening experience. As a general rule, buy the best paper you can afford.

Hot pressed

STRETCHING PAPER

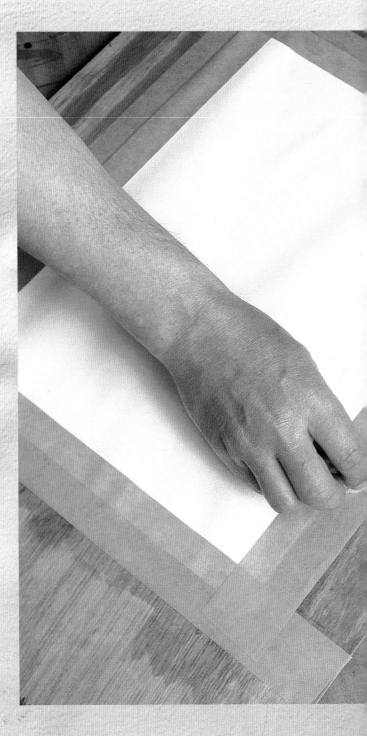

Lightweight papers should be stretched and allowed to dry before you start to paint on them. If you do not do this, the chances are that your paper will wrinkle as soon as you wet it and your painting will be spoilt.

To stretch a sheet of paper, wet it thoroughly, either by wiping it with a damp rag or sponge or by immersing it in water. The wet paper must then be taped to a board and allowed to dry. Do not remove the paper from the board but work on the stretched sheet while it is still taped down.

Even with stretched paper, you will often find wrinkles appear when you apply the paint, but these will smooth out as the painting dries. Only when the painting is finished and completely dry should it be removed from the board.

Saving time

Stretching is a very simple process but it can be irksome if you have to stretch a sheet every time you want to do a painting. The answer is to stretch several sheets at the same time, so that you have a supply of supports ready to work on. You should never try to speed up the process by drying the stretched paper with a hairdryer or by placing it against a radiator. It must be allowed to dry naturally; otherwise it will dry too quickly and tear.

Ask a timber supplier for offcuts of sturdy plywood to use as boards (hardboard and other flexible materials are not suitable because they will bend as the paper dries). The stretched paper can remain taped to the plywood ready for use, and you will be able to use these inexpensive boards over and over again.

Stretching paper

△ 1 *Start by thoroughly wetting the paper, either with a sponge or large brush or by immersing the sheet in clean water.*

◁ 2 *Use gummed paper tape to stick the wet sheet to a flat board. The tape should overlap both paper and board by ¾ in (2 cm) all round. If your tape is not wide enough for this, use two or three widths of tape.*

△ 3 *Corners are the most vulnerable areas because they occasionally pull away from the board as the paper dries. It is therefore a good idea to anchor and strengthen the corners with drawing pins.*

BRUSHES

Buying brushes is probably the most difficult part of setting up. Such a wide variety is now available, in so many shapes, sizes and materials, that choosing the right ones can seem a bit of a gamble.

For watercolour painting, brushes must be soft. They are made of animal hair or a synthetic equivalent. Some artists will use only the traditional natural brushes; others find good-quality synthetic brushes are springier to use and keep their shape better. Natural or manufactured is a question of personal preference, and the only way to discover which suits you best is to try them both. Cheap brushes should be avoided because of their inferior shape and texture, as should the so-called 'craft'

Natural hair *The large wash brush is made from squirrel; the smaller brushes from pure sable.*

Mixed fibre *The bristles are a mixture of sable and synthetic materials.*

Brushes
Watercolour brushes are soft and made with natural or synthetic bristles. A brush may have either a round or flattened head of bristles, and this shape determines the mark the brush makes. 'Rounds' hold more colour and, depending on the size, are used for painting undulating lines and detail as well as large areas of colour. 'Flats' are useful for painting wide lines and for blocking in broad expanses.

brushes. These are intended for children, model-makers and other types of hobby workers, not for serious watercolour painting.

The best natural brushes are made from sable or kolinsky. Only the tip of the tails of these small mammals are used in the finest brushes and, provided they are well looked after, the brushes will remain tough yet soft, and retain their superior shapes for a long time. Oxhair and other hair mixtures are also used in the production of watercolour brushes.

Synthetic brushes *The bristles are manufactured and contain no natural fibres.*

In a good-quality brush, the ferrule (the metal tube that holds the bristles in place) is constructed in one piece and has no seam. This ensures that the bristles and handle are held firmly in place with none of the stray hairs or wobbliness often found in cheaper products.

Shapes

Watercolour brushes are made either with a traditional round ferrule or with a slightly flattened ferrule to produce a chisel-shaped bristle head. Some painters work with the round brushes only, finding them versatile enough to produce all the marks and effects they want to make. Others find a combination of both types gives them greater flexibility. A round brush with long bristles is known as a rigger and is useful for thin, undulating lines. Special fan-shaped brushes are made for blending colours together.

For laying washes you will need a large, round-headed brush. Some artists prefer to use a broad, flat-headed brush for laying washes but, although this may sound a more logical choice, it holds less paint than a traditional round brush and is no easier to use. By all means try both, and use the one that suits you best. A good wash brush is not cheap but it is a necessary investment, so buy a quality one and look after it carefully. It will last you a long time.

Sizes

Brushes come in a wide range of sizes, from the very largest, used for laying broad washes, to the tiniest, which are used for spotting in colour. Sizes depend on the manufacturer, but generally run from 0 to about 16 and larger. The largest wash brushes frequently have no specific size. The smaller spotting brushes are 0, 00 and 000, or -1, -2 and -3. Again, this depends on the manufacturer.

CHOOSING BRUSHES

A few well-chosen brushes are all you need to start with, especially as you do not really know what suits you best until you have tried it. For instance, it is unlikely you will need any brush smaller than a 1 or 2. Anything less than this is used mainly for technical work, such as retouching photographs or mechanical illustrations.

The marks they make

A round watercolour brush has a fine point, whatever its size, and this can be used for quite delicate work. In some of the demonstrations that appear later in this book you will see that just one or two brushes have been used – neither of them particularly fine – and detail has been added with the tip of the brush. The artist says that should a situation arise where only one brush is allowed, this one would be a Number 10 round, because it could cope with both broad areas and with detail.

Round brushes are more versatile than flat ones, because they enable you to paint a regular line by applying an even pressure as you go along, yet they also allow you to vary the thickness of the line by pressing lighter or harder. A flat brush, on the other hand, makes it easier to paint a regular line but more difficult to achieve a flowing or undulating one, because the width of the line is limited by the width of the bristles.

Keeping colours separate

As you progress, you will find that possessing several brushes has a definite advantage. Throughout a painting, it helps to keep the same brush for the same colour, or group of colours, helping them to stay bright and clear. For example, if you have strong reds and greens in the subject, these can become muddy if you switch constantly from one to the other using the same brush, because any trace of red in green, or green in red, can eventually turn both colours into a dingy brown. It is also useful to have clean, dry brushes to hand for soaking up excess colour.

▷**Large round** *Probably the most versatile of all brushes, a large round holds enough colour to cover large areas, yet has a point which can be used for detail and fine lines. Here the artist applies pressure to create a line that swells smoothly from fine to chunky.*

Making brushes last

Good brushes last a long time if you look after them properly. Wash all brushes carefully after use. Gently reshape the bristles while they are still wet and allow them to dry naturally. Never stand brushes bristles downwards in the water, even for a short time. Once its bristles have become flattened or splayed, a brush never regains its former shape.

Choosing your brushes

A good, all-round basic selection would include a wash brush for flat backgrounds and large areas of colour; a few rounds – say, Numbers 2, 4 and 6; and a rigger for linear work, such as tree branches. You might also wish to include one or two flat brushes – say Numbers 2 and 6. Obviously, as your needs increase, this basic selection can be supplemented to suit your own requirements.

◁ **Rigger** *A rigger has long, flexible bristles which allow the artist to paint regular, fine lines with a natural, flowing feel. It is also useful for adding final, linear detail.*

▽**Flat brush** *Broad, regular strokes of colour are best applied with a flat brush. The bristles are cut to create a chisel-effect that gives the artist a great deal of control over the painted line. A flat brush can be turned to create a narrower though more irregular mark.*

▷**Small round** *Finer brushes should be used to supplement larger sizes, and are good for fine lines and detail. For beginners, there is a tendency to work with brushes that are too small for the purpose, and for paintings to become tight and overworked. A good rule of thumb is to use large sizes for all but the final touches.*

PAINTS

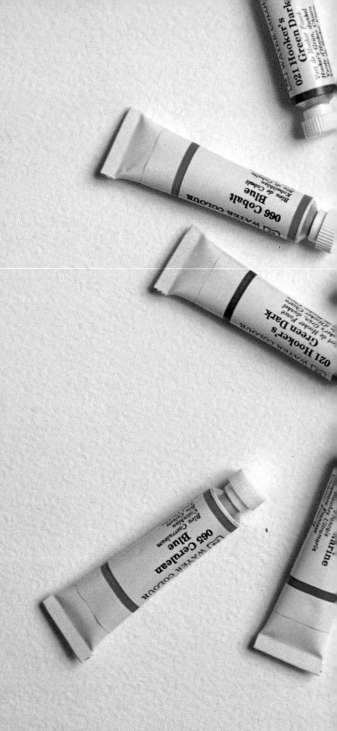

Colours come either in tubes, pans or half-pans. Tube paint is more fluid, and is squeezed out on to the palette before use. It is then diluted before being applied with the brush. Pans and smaller half-pans are solid and semi-moist and the colour has to be released by adding water. The paint is taken to the palette or paper with a brush – as with the boxes of paints used by children.

The type of paint you choose is a question of personal preference. Initially, tubes are probably the most convenient, although there is always a certain amount of wastage – there is always some unused paint when the picture is finished. It is a good idea to experiment, trying both pans and tubes in order to see which suits you best.

It is unlikely that any artist has used the whole of the vast range of watercolour pigments now available. Depending on the manufacturer, there are between sixty and eighty colours to choose from, and the number is increasing all the time. Most painters develop their own favourites and work with less than a quarter of the colours available; some use far less.

Sets and boxes

Pans and half-pans are available in boxes, making them handy for carrying around. The pans are removable, so when a colour runs out you can simply buy a replacement. With most metal paint-boxes, the lid doubles up as a mixing palette, and some boxes also contain a built-in water container. These all-in boxes are very compact and can be slipped into your pocket for sketching and small-scale outdoor work.

Tube paints are also available in sets, usually containing a selection of ten or twelve colours and often a palette, brush and painting pad. The sets make welcome gifts for someone interested in learning how to paint, but a prolific painter will very soon find it necessary to supplement the contents with more brushes and a wider range of colours. Given the choice, it is probably better to make your own selection in the first place.

Colour and quality

Paints are produced in two grades: quality 'artist's' colours and a less expensive range, some of which are made with cheaper pigments. Although the quality paints cost more, any artist will tell you that the extra expense is well worth it – the colours are stronger and more vivid, the results more satisfying. And when you consider just how far a small amount of paint will go, and just how long one tube or pan will last, it is generally best to opt for the superior product.

Certain pigments are more long-lasting than others which fade over the years as they are exposed to the light. The degree of colour per-

Tubes

Half-pans

Pan

Tubes, pans and half-pans *Tube colour contains more moisture than the semi-moist pans and can be squeezed directly on to the palette. When using pans and half-pans, colour is loosened with a wet brush.*

manence is generally indicated on each tube, usually with ✳✳✳✳ for permanent, ✳✳✳ for normally permanent, ✳✳ for moderately permanent and ✳ for fugitive (likely to fade).

You will also notice that colours vary in price and that the cadmium and cobalt colours, for instance, are more expensive than most of the earth colours. This is because some pigments are harder to obtain than others, and are priced accordingly.

CHOOSING AND USING PAINTS

Most artists work within a personal colour range, using colours that have become favourites over a period of time. Some colours – such as black and white and the primaries red, blue, yellow – are common to almost every palette; others are less common, used only occasionally or by relatively few painters. To help you decide which colours you like, it is a good idea to start with a basic selection, or palette, and introduce one or two new colours from time to time.

A 'starter' palette

The following is a standard beginner's palette, recommended on many art courses and containing a basic range of colours to get you going: cadmium red, cadmium yellow, French ultramarine, cerulean blue, yellow ochre, lemon yellow, raw umber, burnt sienna, crimson alizarin, viridian, Chinese white and ivory black. You will be surprised how versatile these twelve colours are, and how many other colours can be mixed from them.

Early follow-ups are likely to be Payne's grey, cobalt blue, cobalt violet, rose madder, Indian red and Hooker's green 1 and 2.

The projects and step-by-step demonstrations in this book are all done with the above colours.

Mixing paints

Watercolour painting requires an orderly approach, especially when it comes to mixing colours. However creative you are, and however uninhibited your painting, a few minutes spent laying out the brushes, colours and palettes before you start will help you keep control of your work and generally make life a lot easier. It is absolutely essential to wash your brush thoroughly between colours and to change the water frequently.

To mix enough of one colour to cover a fairly large area, or of a colour that you will need frequently, use a single mixing-dish like the one shown in the photographs here; otherwise use a white saucer or small dish. For small amounts of

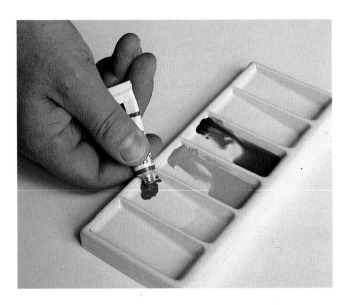

Mixing from tubes
△1 *Squeeze the colours you require on to the palette. A palette with separate mixing compartments, like the one shown here, will allow you to squeeze several colours at the same time.*

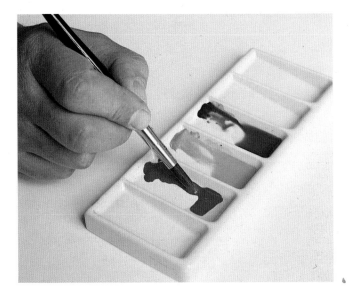

△2 *Add enough water to make the paint workable with a brush, then mix the colours in exactly the same way as for pans and half-pans.*

colour, the mixing method depends on the type of paint. If you are using tubes, squeeze a little of the colours you will need on to the palette or plate, then mix each new colour as you need it. When working from pans, simply mix each new colour as required by lifting the colours to be mixed from the pan with the brush and transferring these to the mixing palette.

Colours change as they dry, so keep a sheet of paper to hand for testing the mixed paint. Allow each test to dry before applying the colour to the painting. A hairdryer will speed up this process.

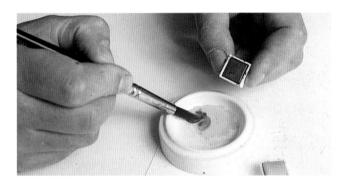

△ 2 *Wash the brush thoroughly in clean water and add a second and subsequent colours in the same way. The brush should be washed before you return to the pan for more colour.*

Mixing colour: pans and half-pans
▽1 *Dip your brush in clean water and work this into the paint until it softens. Transfer the first colour to the mixing dish or palette with the brush. If you want to mix a fairly large quantity of colour, you will need to do this several times.*

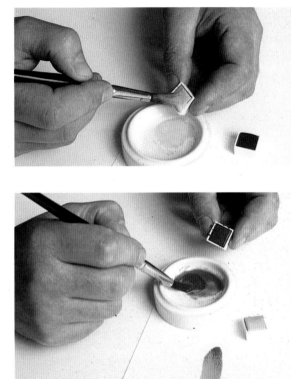

△3 *Continue adding paint until you have the colour you require. Watercolour always looks darker in the mixing dish than it does on paper, so keep a scrap of paper handy for testing your colours.*

◁4 *Continue mixing and testing your colour until you are happy with the result. The more water you add, the paler the colour becomes. Watercolour tends to dry lighter, so for an accurate indication of how a colour will look, you must wait for the test to dry.*

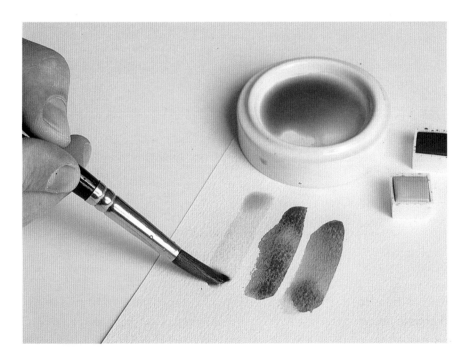

29

WATERCOLOUR ADDITIVES

Various substances can be added to watercolour, varying the consistency of the paint to produce a whole range of textures and finishes. The additives can open new vistas to the adventurous painter who likes to experiment and create new effects. When used selectively, they can also enliven traditional painting techniques and give a lift to work which has started to go flat or dull.

It must be stressed, however, that no medium is a substitute for the paint itself. You can improve the surface texture, give an added glow to the colour, and create certain patterns and effects that would not be possible using paint alone. But you cannot depend on an additive to compensate for lack of painting skill, to disguise a bad composition or to rescue a painting that has already been ruined by impatience or overworking. Additives should be regarded as occasional enhancers to your work, and should not be overdone.

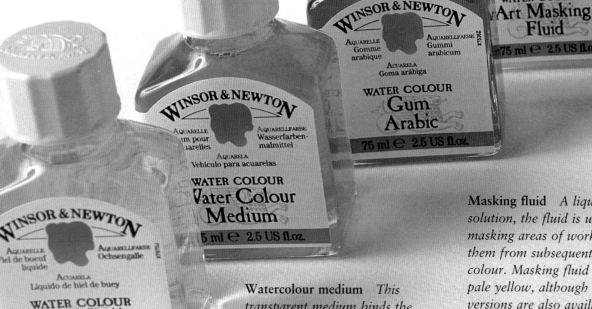

Masking fluid *A liquid rubber solution, the fluid is used for masking areas of work to protect them from subsequent layers of colour. Masking fluid is normally pale yellow, although colourless versions are also available.*

Watercolour medium *This transparent medium binds the colours and improves the flow of the paint. It can also be applied to wet colour to create texture and pattern.*

Gum arabic *A slightly viscous medium, gum arabic binds and thickens colours, which then dry with a glossy sheen. It can also be applied to wet colour to produce patterns and textures. Gum water is a thinner version of gum arabic and produces similar effects.*

Ox-gall liquid *A wetting agent used to improve the flow of colour, ox gall makes it easier to apply watercolour across the paper surface.*

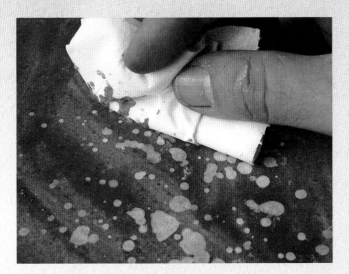

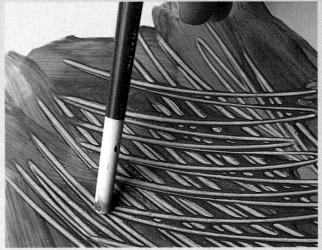

Gum Arabic
△*Normally mixed with the paint to brighten and enhance the colour, gum arabic can also be used to create a variety of textures. Here the artist flicks drops onto an area of dried colour to get a mottled effect.*

Texture Paste
△*A clear, jelly-like substance, texture paste is mixed with the paint in order to thicken it without affecting the transparency. Scratched patterns can be made in the wet, thickened colour to reveal the paper or underlying colour used for scratched patterns.*

Experiment first
The most common additives are oxgall, gum water and gum arabic, watercolour medium and texture paste. Masking fluid is not actually added to the paint but is applied separately. With all these substances, it is important that you know how to use them – to understand exactly what the possibilities and limitations are – and this can be done only by practice. Certainly, you should never attempt to introduce any of them into a painting unless you have first tried them out.

Aquapasto *This transparent texture paste is mixed with watercolour to give a thick consistency. The colour retains the shape and texture of the brush marks and enables the artist to scratch back into the paint to reveal the paper or underlying colour.*

EASELS AND OTHER EQUIPMENT

Some watercolour equipment can be improvised, but not your easel. It is especially essential if you are going to work out of doors. As this is the largest item on your equipment list, it is worth getting a good one.

should also be stable. Some artists like to work with the board almost horizontal on the easel; others like to paint at an angle, a tilt of around 45 degrees being the most usual. Many find it easier to sit at their painting with their materials spread out on the ground, so make sure your easel allows you to do this.

Other equipment

If you are working on sheets of paper as opposed to a block or pad, you will need a drawing-board and clips for holding the paper in position. You will also need a folding stool and a bag to carry paints and equipment.

Mixing dishes

The right easel

A proper watercolour easel is adjustable, enabling you to work at any angle, including horizontally – essential when you are using a lot of wet colour, otherwise the paint just runs down the paper. A sketching easel has a certain amount of tilt but does not adjust to a full horizontal position.

Try to find an easel which is sturdy yet light enough to be easily portable. The majority come in beech or other hardwoods, but there are some made in lightweight metal which fold up very compactly. Your easel should have telescopic legs to adjust the height and enable you to work standing or sitting. It

Cotton buds

Standard drawing-boards can be bought at any art or graphic supplies shop. A good one will last a lifetime, provided you look after it and don't use it as a cutting-board. Some boards are far too big and heavy to carry around, so choose one which is best suited to your needs. A cheap, lightweight alternative is a sheet of plywood, available from your local timber shop.

Watercolour painting requires a lot of clean water, a point often forgotten. Plastic bottles with screw tops are useful water-carriers when working away from home. You should also take plenty of clean rag or tissue with you. As with water, take more than you think you will need.

Natural sponges

Erasers

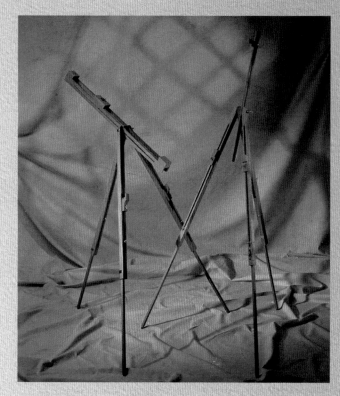

△*A lightweight sketching easel (left) can also be used for watercolour. The angle is adjustable, but it cannot be adjusted to a horizontal position. Adjustable, telescopic legs make the easel compact and easy to carry. The portable watercolour and sketching easel (right) is similarly compact and can be adjusted to a horizontal painting position.*

Palettes

Colours

Colour wheel *The primaries are red, blue and yellow; the secondaries – violet, green and orange – are mixed from these.*

K NOWING HOW to mix exactly the colour you want is a matter of practice and experience. The two commonest mistakes are overmixing and undermixing.

Overmixing is generally caused by lack of confidence. What happens is that we add a little of this colour and a little of that colour, hoping to overcome the problem of not knowing what we are doing. The result: a homogeneous mud-colour.

Undermixing is caused by not looking at the subject. Working automatically without looking, we paint 'a blue sky' and 'a green field'. We fail to see that the 'blue' sky may also contain a fair amount of pink or violet, and that 'green' grass can be mainly ochre or grey.

A wise approach is to look carefully at the subject and then try to mix the correct colour as simply as possible. The following pages give some useful combinations.

The colour wheel opposite shows the basic primary and secondary colours but there are many different versions of every named colour. The number of greens, for instance, is almost limitless, and can be mixed from many colour sources. You can even paint a landscape without using pre-mixed green at all.

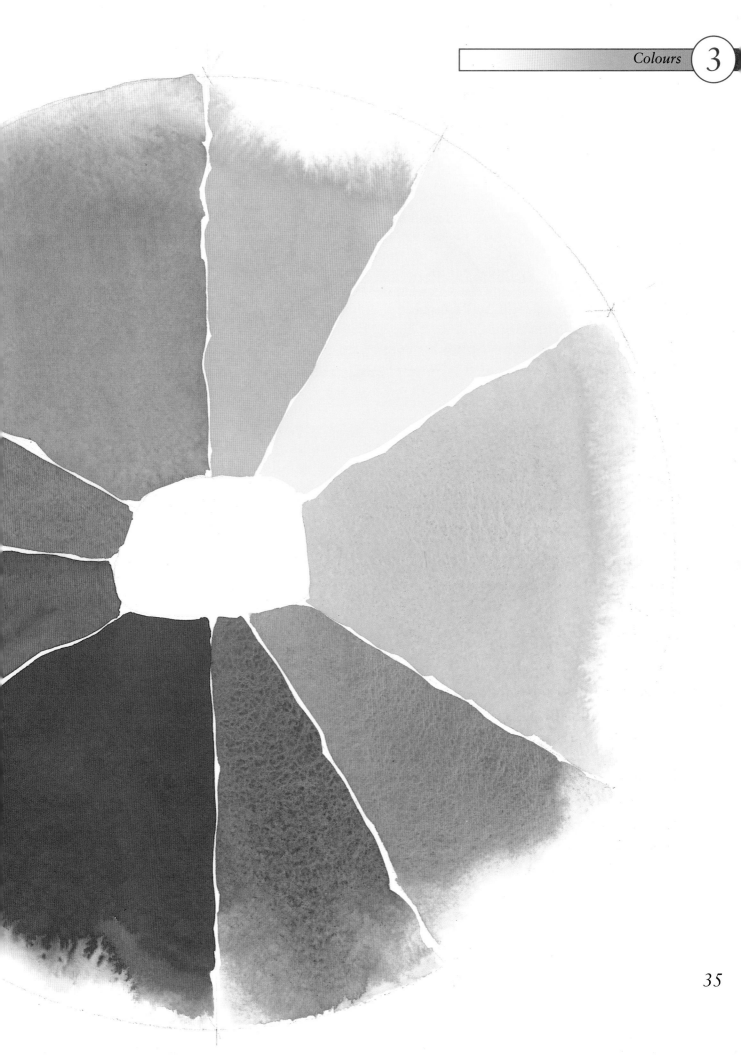

MIXING COLOURS

Colour mixing is a visual skill which cannot effectively be learned from books and charts. The only way to find out about it is to get out your paints and have a go. By trying out all possible combinations, you will not only discover what the possibilities are but you will also remember the properties of the colours you use.

The colours shown here are the suggested basic palette on page 28. They are an excellent starting-point, and from these foundations you can go on to mix an almost infinite variety. Try making your own colour chart, taking one colour at a time and mixing it with each of the other colours on your palette, in varying quantities. Very soon you will have at your fingertips a comprehensive repertoire of your own colour recipes.

Cadmium Red

Cadmium Yellow

Cerulean Blue

Yellow Ochre

Raw Umber

Burnt Sienna

Crimson Alizarin

Cobalt Blue

Cobalt Violet

Rose Madder

The important greens

For the landscape painter, green is one of the most important colours. Many of the ready-mixed greens, particularly viridian, are too strong to match the subtleties of most landscape subjects, although a strong green is often useful for brightening up an otherwise dull green. In nature, greens are often dominated by another colour, such as blue, violet, lemon, golden yellow, red or brown, so to assume that green is a simple mixture of blue and yellow is far from the truth. You can paint the leafiest landscape without any green in your palette.

Similarly, you should not assume that the only way to get orange is to mix primary red with primary yellow, or that primary blue and primary red make the only possible violet. Try using the many reds, yellows and blues shown here, and you will be surprised at the rich assortment of oranges and violets you get.

◁ *The colours shown here are those in the suggested 'starter' palette on page 28.*

nch Ultramarine

Lemon Yellow

ridian

Ivory Black

Payne's Grey

lian Red

Hooker's Green 1

Hooker's Green 2

LIGHTS, DARKS AND NEUTRALS

Some colours are dark; others are pale. For the artist this simple, obvious fact is important because the arrangement of light and dark shapes in a painting can be as crucial as the colours themselves.

Tones

The degree of lightness or darkness of a colour is known as a tone or tonal value. Thus yellow, pink and other pastel shades are all pale tones, while the darker colours are all deep tones.

When using watercolour the palest tone is the white paper, the darkest is black or near-black. If a painting gets overworked, the lights and darks start to merge. The painting loses its sharpness and you can end up with a rather flat-looking picture.

Similarly, if you work only in bright colours, the vividness of each individual colour is diluted because it is cancelled out by its neighbour. For example, a bright red looks particularly vivid if it is surrounded by greys and neutral colours, but when painted next to other equally vivid colours it might not be noticed at all.

Neutral colours

When painting from a subject, it is helpful to remember that we rarely see pure colours around us. We may know that a particular vase is bright yellow, but what we actually see is a mixture of other colours in the form of shadows, highlights and reflections that pick out the surrounding colours – in other words, colours that tone down, or neutralize, the yellow of the vase.

'Neutrals', therefore, play an important part in painting and should not be overlooked in your colour mixing. A neutral colour is one that has been toned down by mixing with another colour. A true neutral has no identifiable colour at all. It has a slightly greyish appearance – an equal mixture of primary red, blue and yellow produces a neutral grey. But practically speaking we also use the term neutral to describe a colour which has been toned

down with another pigment. For example, red and yellow with a touch of blue will produce a neutral orange; blue and yellow with a touch of red will make a neutral green; and so on.

As with all colour mixing, it is not possible to be absolutely precise. The purpose of neutral colours is

Tone and Colour
◁*Every colour can be mixed to obtain lighter and darker tones. The addition of black produces a deeper version of a colour: diluting the colour with water gives you a paler tone. In the central column of this chart are the primary and secondary colours; in the adjacent columns are two darker and two lighter versions of each colour.*

to give harmony and depth to a painting by bringing the other colours together, and at the end of the day it is what works in the painting that is important. So spend time experimenting. Invent your own neutral colours and try introducing them into your paintings.

The basics

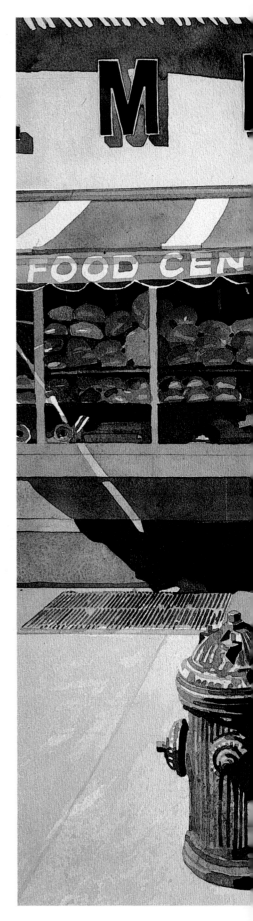

A SUCCESSFUL WATERCOLOUR is rather like a patchwork quilt – built up piece by piece, each an integral part of the finished product. With patchwork, the pieces are sewn together, edge to edge; with watercolour painting, they are usually juxtaposed or overlapped. But each stage, each piece, must be planned and executed with the same amount of patience and precision.

Once you get used to building up a painting and – if necessary – waiting for the colour to dry between stages, the process becomes very much easier.

The first 'piece' to go into many watercolours is the background or, in the case of landscapes, the sky. This is usually done by laying an area of thin, flat colour known as a 'wash'. This should present no problem provided you follow the step-by-step demonstrations and work in a logical and systematic way.

Whether you paint on to the wash while it is damp or wait until it is dry depends on the effect you want a crisp shape, or the colours run slightly for a softer effect. Before embarking on an actual painting, it is a good idea to try painting on to surfaces that differ in their degrees of dampness so you know exactly what the results will be.

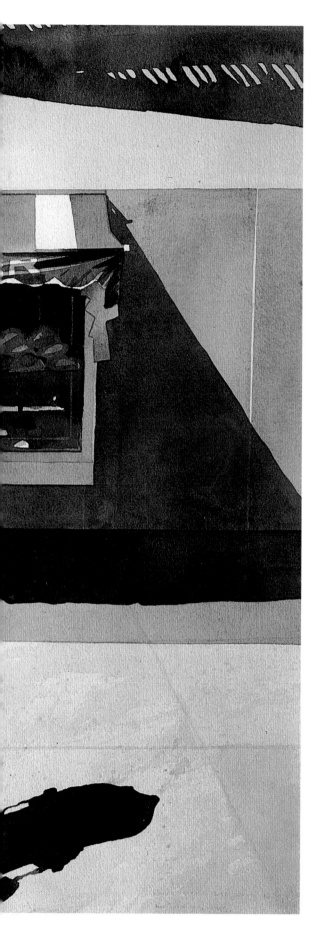

▽**Wet on wet** *A misty morning in Venice is captured in washes of mixed greys. To achieve this hazy, undefined effect, the artist painted on to wet paper, allowing the colours to run and mix freely.*

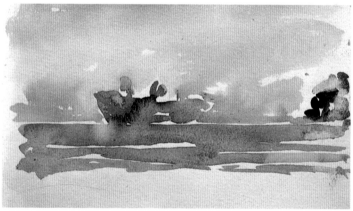

◁**Wet on dry** *Hard shapes and crisp details are used to depict this urban street with its picturesque bakery. The clear shapes are the result of allowing each colour to dry before applying subsequent colour.*

LAYING A WASH

Laying a wash is the most fundamental of all watercolour techniques, useful for backgrounds, skies and any other wide expanses of colour. Strangely enough, it is the one technique which seems to cause the most problems although it is actually very simple to do.

Use quality paper
Use a fairly heavy, good-quality paper. The paper will get completely saturated so anything less than 150 lb (68 kg) must be stretched. The brush must be well loaded with colour when you paint each strip,

so a large brush is essential. A standard wash brush has a round ferrule because this holds more paint than the flat variety. However, some artists get better results with a flat brush, so it is worthwhile experimenting and finding out which works best for you.

Technically you should be able to produce a flat wash which is completely even with no tidemarks or drips in the colour. However, watercolour painting rarely calls for such a pristine effect, so unless that is what you particularly want, don't worry if your wash looks a bit patchy. In any case, much of the unevenness disappears when the colour dries. Whatever happens, never tamper with the wash once it has been laid. It is always a mistake to go back and try to paint over what you have done, and you will almost certainly end up having to do the whole thing again.

Occasionally a wash can turn out rather grainy,

Laying a wash
▷**1** *Mix enough colour to cover the area you are painting. Watercolour tends to get lighter as it dries, so test your colour on a sheet of paper and allow the test to dry before committing the colour to your painting.*

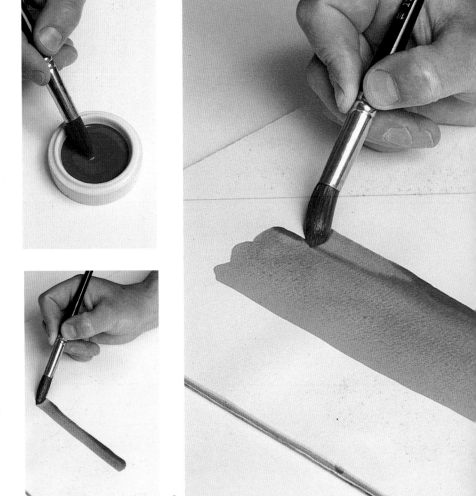

▷**2** *Before starting to paint, tilt the board sufficiently to allow the colour to run slowly downwards. Load your wash brush with plenty of paint and apply the first stripe across the top half of the wash area.*

with particles of pigment floating around in the colour. Certain colours are more prone to this granular effect than others, and some blues seem particularly inclined to separate in this way. Usually the wash will look better once the paint has dried and, in any case, a few grains are rarely detrimental to the finished painting.

Tilting the board

A wash is laid in a series of broad, slightly overlapping strips. As the artist paints each new strip, surplus colour from the preceding strip is collected up with the brush. The angle of the support is all-important. It should be tilted enough for the paint to collect at the lower edge of each strip ready to picked up, but not be so steep that the colour runs down the paper in an uncontrollable way. Never attempt to lay a wash with the board placed on a flat surface.

Watercolour is soluble, so even after it has dried, there is a danger involved in laying more wet colours on top. Watercolour has a tendency to dry considerably lighter than it looks when freshly applied. So if your wash turns out to be too pale, you cannot put another wash on top of it and hope to get a flat colour. The colour beneath will be disturbed and the result will be blotchy. It is therefore important to get the right consistency in the first place. Not only must you test your colour on a separate piece of paper; you must also wait for the test to dry.

▽3 *Continue with the wash, reloading the brush for each new stripe and allowing each stripe to overlap the preceding one. This allows the brush to pick up residues of colour collected on the lower edge of the preceding stripe.*

▽4 *When you have covered the required area, wash the brush and squeeze out excess moisture. Drag the clean brush along the bottom of the last stripe, collecting final residues which may otherwise run or dry too dark.*

The quality of the finished wash depends to a large extent on the quality of the paper, which should be heavy and good. Never be tempted to touch up or work into a wash, because this will inevitably ruin what you have done.

TECHNIQUES

GRADED WASH

A flat wash painted on to white paper is often the starting-point for a watercolour, but there are exceptions. Sometimes, a flat wash proves an unsuitable starting-point for a painting; once you have painted an even colour all over the paper, you will not obtain absolute brilliance from subsequent layers because of the universal underlying tone. You will therefore often need to lay a base colour that is less even and leaves an area of unpainted paper. In cases like this the artist will often employ what is known as a 'graded' wash.

If you are using a wash as a background to a still life, figure or landscape painting, you will often look for an effect that fades out towards the bottom half of the paper, leaving you with plenty of white space on which to develop the main subjects. For example, if you are painting a landscape and lay a bright sky colour across the whole page, it will affect the greens and other landscape colours which have to be painted over it. It is better to allow the sky colour to fade out gradually towards the horizon, so that the lower part of the paper is white enough to be painted on without affecting the colours.

The method for laying this fading, or graded, wash is almost the same as that for laying a flat wash, except that water is gradually substituted for colour as you proceed down the paper.

Laying a graded wash
▷1 *Mix enough paint for the job, then apply a broad stroke of colour along the top of the area to be painted.*

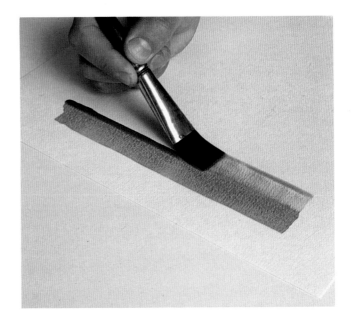

▷2 *Working quickly, wash the brush and drain it slightly. Run the wet brush along the lower edge of the stripe.*

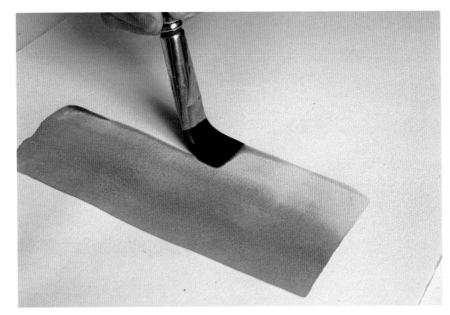

Wet wash

You might find it easier to paint a graded wash if you dampen the paper first. To do this, apply the water with a sponge – the surface should be damp, not wet – and make sure the board is tilted at an angle of at least 60 degrees. Load the brush full of colour and apply in strips, starting at the top. The damp surface absorbs the colour, which gradually loses its strength as you work down the paper.

For larger areas, an alternative way is to apply the colour with a sponge instead of a brush. Wet the sponge and squeeze out any excess water. Load it with diluted colour and apply this in slightly overlapping strips, starting at the top. As the colour gradually runs out, it becomes fainter and you are left with a graded sheet of paper.

Variegated wash

By working with more than one colour you can create a variegated wash. Do this by mixing two or more colours and overlap these across the dampened paper.

Variegated washes are highly unpredictable because the colour does not dry in even stripes but tends to form its own patterns and shapes. They can, however, be very beautiful and unusual, and can often form the basis for further painting.

▽3 *Again, dip the brush in clean water, drain it slightly, then pull it along the bottom of the last stripe.*

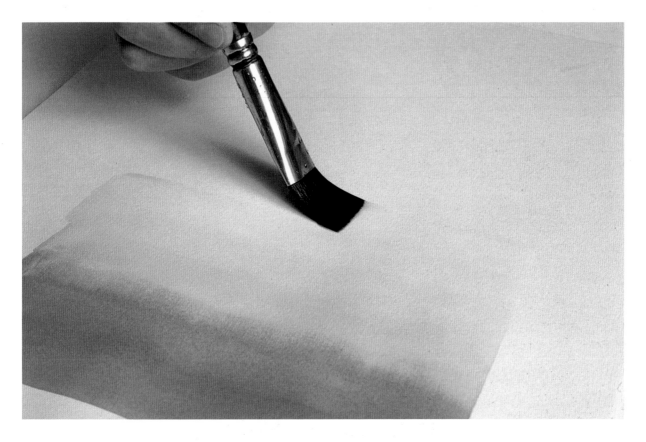

◁4 *Continue working in this way until the colour completely disappears or until you have covered the area required.*

TECHNIQUES

WET AND DRY EFFECTS

There are two distinct approaches to watercolour painting, each producing very different results. One involves painting on to a wet surface, either wet paper or wet paint, allowing the colour to run and form its own fluid patterns. The other involves applying the colour to a completely dry surface, so that the brushmark retains its shape.

Wet on dry
Painting on to a dry colour gives absolute control over the paint, and is perhaps the easiest approach to watercolour painting. The secret is to allow every colour to dry completely before laying other colours.

When painting on to dry colour or a sheet of dry paper, the paint sits on the surface in exactly the place you apply it. You can paint up to a drawn line with great precision, but the technique should not necessarily limit you to working precisely. You can paint 'wet on dry' very loosely with a large brush or use broad areas of overlaid and overlapping colour to create free patterns and shapes.

The transparency of watercolour means that the underlying colour will always affect the newly applied one. Yellow over red will produce orange, yellow over blue will produce green, and so on. Depending on the staining power of the colours you use – some are stronger than others – the top colour will usually dominate the underlying one. Thus red over yellow will produce a darker, more reddish orange than yellow over red.

As you do not have to wait for each colour to dry naturally, a hairdryer can speed up your work.

Wet on wet
This is the term used when colour is applied to a wet surface – to the paper, deliberately dampened to receive the paint, or to an area of wet colour. The

1 *Painting on to dry colour*

2 *Painting on slightly damp colour*

3 *Painting on to very damp colour*

4 *Painting on to wet colour*

△**Wet on wet** *Painting wet on wet produces an amorphous, watery image, slightly 'out of focus'.*

colour bleeds and runs as it comes into contact with the wet surface, giving a soft, amorphous shape.

A picture painted entirely wet on wet has no hard lines and no structured shapes. This is fine if it is particularly what you are aiming for, but such a lack of control can be rather alarming and for this reason wet on wet is usually done in selective areas of a painting. This allows the artist both to control the forms in the picture and to introduce spontaneous runs of mixed colour.

The degree of dampness of the paper is important here. Working on very wet colour allows almost no control and the colours and shapes are entirely random – although sometimes very beautiful. On the other hand, if the paper or underlying colour is just slightly damp, the painting can be fairly specific but the shapes of colour will look slightly out of focus. Practice will tell you just how damp your support should be to obtain a particular effect.

▽**Wet on damp** *Painting onto slightly dampened paper gives control over the colour, but shapes have a soft edge.*

▽**Wet on dry** *The same subject, painted wet on dry, is crisp with sharply defined shapes, colours and patterns.*

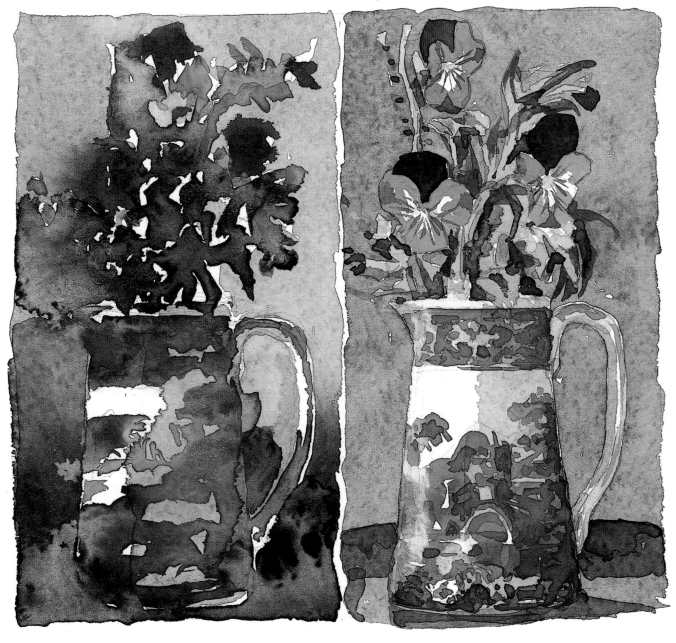

DRAWING FOR PAINTING

Before you can start painting, you will generally have to make a drawing of the subject. This does not have to be complicated – indeed, the simplest of outlines usually produces the best results – but it does have to be accurate. The drawing must also contain enough information to act as a guide once you start painting.

When planning your painting, try to leave a broad margin of paper around the proposed picture area. This gives you the opportunity to change the composition and size of the painting even after you have drawn the subject.

For instance, if you mark out the rectangular shape of your painting lightly in pencil but then decide the subject looks cramped, you can make the picture larger by simply redrawing the edges. Conversely – and this is a far more common mistake – you might decide your subject is too small in relation to the picture size. In this case, you can crop the picture to make the composition more compact.

Pencil drawing

Drawing for watercolour is traditionally done with graphite pencil. This is probably still the most popular method because the lines can be drawn so

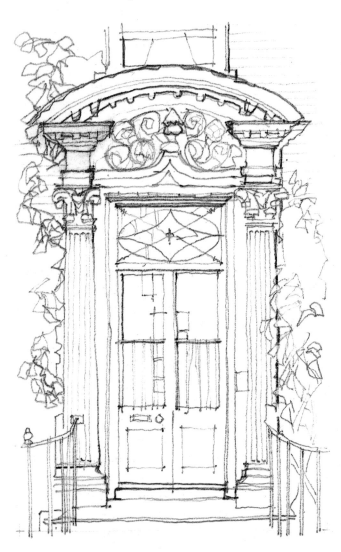

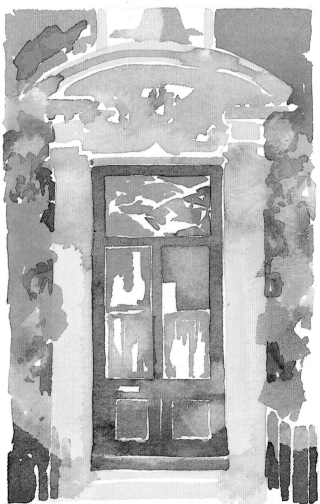

△**Watercolour** *Colour is sometimes applied without a preliminary drawing.*

◁**Pencil** *Soft pencil lines can be erased when the painting is complete.*

▽**Resist** *Wax crayon resists a subsequent watercolour to give a textural effect.*

△**Pen and wash** *Traditional dip pen and ink work well with watercolour wash.*

lightly they do not show through the paint, or at least they can be rubbed out. Many artists find it difficult to make an accurate drawing that is also simple enough for watercolour, but using pencil enables you to make a lot of lines, and to redraw and correct mistakes. You can rub out all but the essential lines before starting to paint. For this reason, the newcomer to watercolour will find pencil a sympathetic drawing medium.

Positive outlines
Another way of working is to be deliberately bold with the outlines, incorporating them into the painting and even making a feature of them. For

instance, pen and wash has been a favourite with painters and illustrators for centuries. In this case, the drawing is usually in waterproof ink, often brown or sepia, and colours and tones are washed in lightly with watercolour after the ink has dried.

Some artists begin by making a drawing with the paint itself. This can be done very lightly in the local colours of the subject, so that the outlines eventually become blended into the rest of the painting or you can use one colour for the whole drawing, painting the outlines quite boldly so that they become a unifying feature in the finished painting.

A similar effect can be achieved with coloured pencils or even wax crayons. Again, you can use lots of colours in the one painting, or you can pick one colour and make this into a feature. Crayons, coloured pencils and other chunky drawing materials also lend a contrasting texture.

PROJECTS

VEGETABLES

Coloured outline

Bright, bold outlines were the starting-point for this colourful arrangement of vegetables and fruit. The artist wanted to demonstrate how an imaginative drawing can play a crucial role in the painting as a whole, and how colour is an important part of a picture, even from the very outset.

Line and colour

This subject was chosen for its bright local colours – red, orange, lemon yellow, deep purple and a range of greens – and the approach is not strictly representational. In other words, the artist's concern does not lie with creating an accurate visual description of the subject or with making the vegetables look 'real'. The emphasis is on colour and line, and deep shadows have been deliberately simplified in order to emphasize these elements. The composition too is very straightforward – a virtually symmetrical subject placed centrally on the paper.

The coloured drawing approach is excellent for beginners. It enables the artist to concentrate without distraction on the two most important aspects of watercolour: colour and drawing. Although we have chosen a particularly multicoloured subject to give as much variety as possible, the same approach can be applied to any subject, even a low-key one. A rural landscape, for example, might be drawn out in various greens and browns; a seascape, in blues and greens.

Materials to use

The artist chose water-soluble crayons in order to blend the outline into the subsequent washes of colour, but there are several alternatives. You might prefer soluble or non-soluble coloured pencils, or wax crayons, which resist the paint and give a more textured line. Whatever materials you use, it is important to keep the drawing chunky and loose, and not to restrict it to a tight outline.

△ 1 *Using water-soluble coloured pencils, the artist draws the subject in the actual colours of the various vegetables. Lines are deliberately free and sketchy – an effect achieved by holding the pencil loosely and drawing in a relaxed manner.*

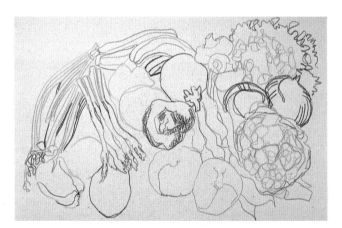

△2 *Coloured outlines are emphasized with water-soluble crayons. Still working in the same bright colours, the artist starts to establish some of the shadows and local colours. Crayons are chunkier than coloured pencils, making them particularly good for rapid blocking in and for working on a large scale.*

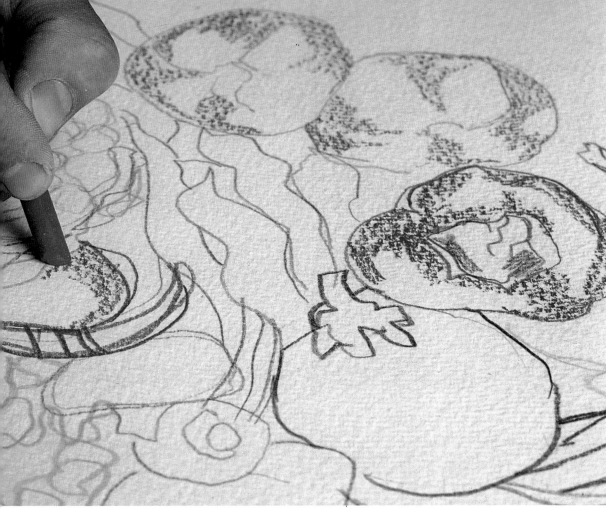

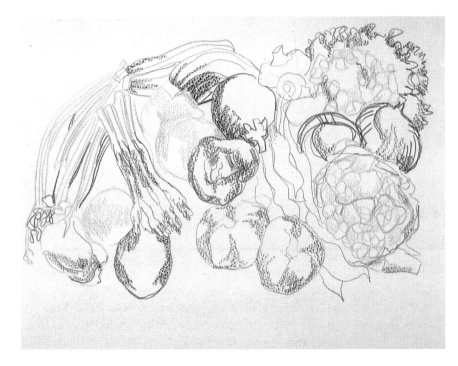

△3 The rounded forms of the vegetables dictate the direction of the crayon strokes. Note how the lines of shading are curved, following the rounded form of each vegetable – a simple technique that makes each object look solid and three- dimensional.

◁4 The artist continues strengthening the subject, using the lines to describe various forms within the subject. Some of the coarse texture created by the crayons will survive into the finished painting; some will dissolve when the paint is applied.

51

△5 *Before starting to paint, the artist checks the whole picture, making sure that the colour density is evenly spread across the image. Here, the lemons are being strengthened with patches of dense, bright yellow.*

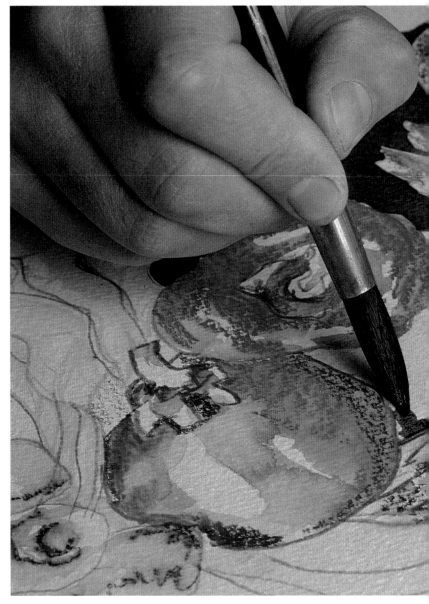

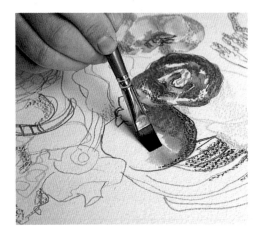

△6 *Clean water is painted across the purple pepper, with areas of white paper left to represent the shiny highlights. The crayonned areas partially dissolve into the water to produce an effect similar to a watercolour wash, but the original drawn areas still remain darker than the washy, dissolved colours. These represent shadows.*

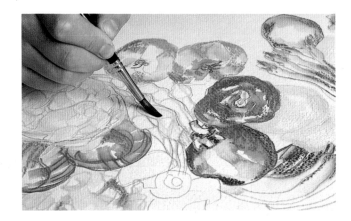

△7 *Still using water only, the artist works into the greens. Some of the crayon dissolves into the paint to produce an effect that is part drawing, part painting.*

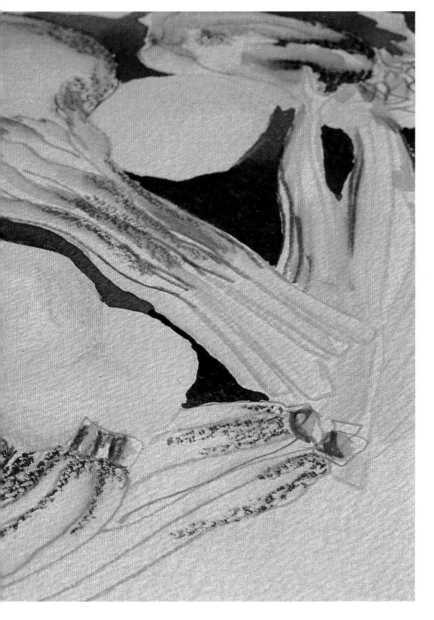

▽8 *So far, the artist has used no paint at all, but has merely dissolved the pencil and crayon with water. Even without paint, the painting is near completion, with all the shadows, local colours and highlights blocked in.*

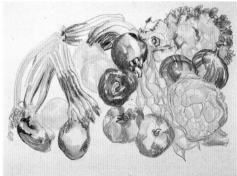

◁9 *Now, for the first time, the artist introduces watercolour paint to suggest some of the deeper shadows between the individual vegetables. Black, burnt umber and Payne's grey are mixed in varying quantities and applied to the spaces between the vegetables.*

▷10 *In the completed painting, the dark painted areas represent both the deep shadows and the table on which the vegetables are arranged. Thus the subject is given a place in space, a real setting. This in turn helps make the vegetables themselves look three-dimensional and real.*

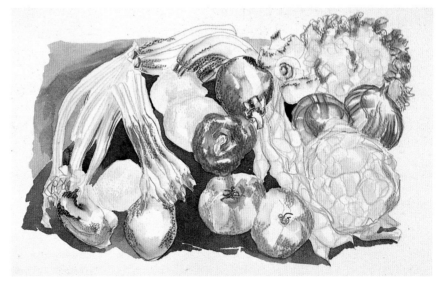

PROJECTS

INTERIORS

Wet and dry

An interior often looks complicated, but it is usually easier to paint than most subjects, provided you tackle it in a systematic way. This room is typical of many, with furniture, ornaments, prints and patterns. It all looks much more difficult than it really is. When confronted with such a subject, do as the artist does in this painting: block in the main shapes and simplify the patterns to give an approximation.

Blocking in

The term 'blocking in' describes the early stages of a painting, when the main shapes are established. Before detail is added, these areas should be painted so that they are approximately the right colour and tone in relation to each other. It is often helpful to look at the subject through half-closed eyes, eliminating detail and enabling you to see the overall colour.

Watercolour tends to lighten as it dries, so in this painting each blocked-in area is allowed to dry thoroughly before adjoining areas are painted. This not only establishes the tones in relation to each other but also ensures that the paint does not run and spoil the hard edges of the blocked-in shapes.

If the blocked-in colour is too flat in the early stages, it can make for a boring picture, so use different thicknesses of paint to suggest shadows or colour variations. Notice how the reflections on the lacquered cabinet are painted as loose, washy patches compared with the deeper local colour.

Wet on wet

Large areas, such as the pink wall, are blocked in with a wash. Here the wallpaper has a large, pale, floral design which affects the overall tone of the wall, so the wet paint is dabbed with a sponge to give a general impression of the pattern.

The curtain, flowers and other selected areas are painted wet on wet, a fluid approach that counteracts the tighter painting of the blocking-in stages.

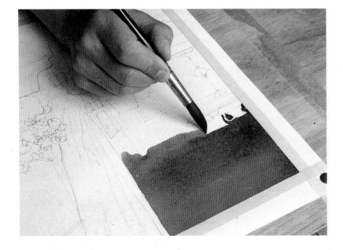

△1 *Having decided which section of the room to include in the picture, the artist starts by making a light line drawing with a 2B pencil. Working from a palette of cadmium red, cobalt violet, Payne's grey, cobalt blue, lemon yellow, burnt sienna, alizarin crimson, black and rose madder, the artist applies a flat wash to the main wall with a mixture of alizarin crimson and black.*

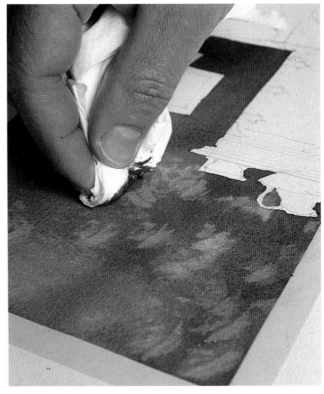

2 *The large floral pattern on the wall is suggested rather than painted, and the artist creates an overall effect by dabbing the wet colour with a tissue.*

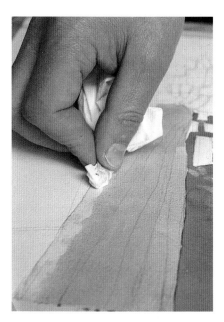

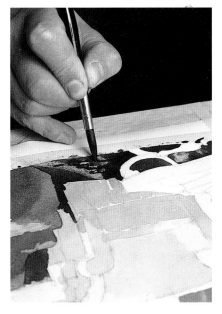

◁**4** *The chair is painted in Payne's grey mixed with cobalt blue and a little lemon. For the surrounding shadow, the artist adds Payne's grey to the pink wallpaper colour.*

△**3** *When the red is completely dry, the adjoining curtain is painted with a thin grey wash. The wet paint is then dabbed off with tissue to indicate where the light falls from the window.*

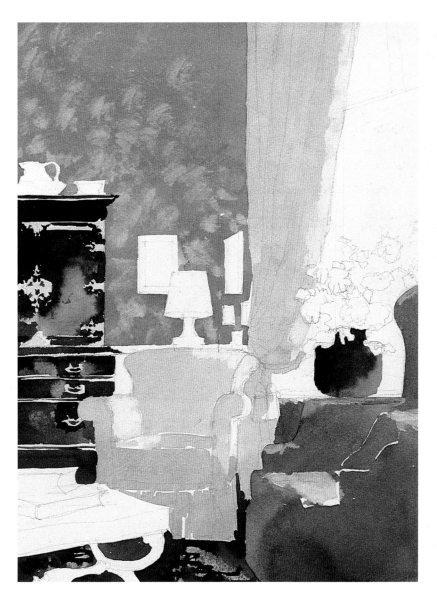

▷**5** *Furniture, floor and walls have been partially blocked in as shapes of colour and tone. Yet space and form are suggested in the way the colour is applied. The chairs look solid and real because surfaces which catch the light are left white or very pale. Similarly, the cabinet is painted in black on to wet paper with large patches left white to indicate the glossy reflections.*

55

▽6 *Bright-orange flowers are painted on to damp foliage, encouraging the colours to merge and blend on the paper.*

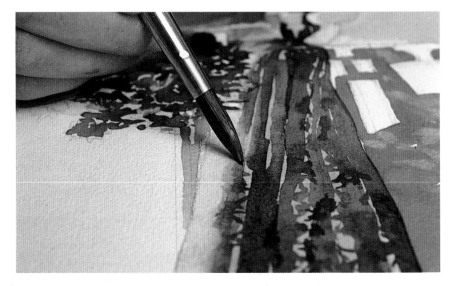

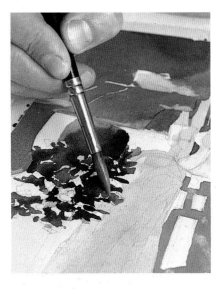

△7 *The curtain pattern is painted, first in broad grey stripes and then, while the paint is still wet, with patterns in red and blue. Again, the colours are encouraged to run and create their own shapes.*

▽8 *The picture is nearing completion, with the main areas now blocked in. Patterns on the chairs, wall and curtain are not painted specifically, but are suggested to give an impression of the overall effect.*

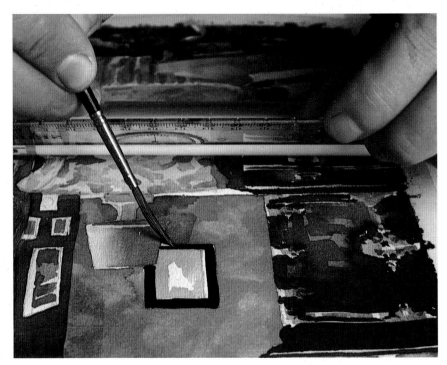

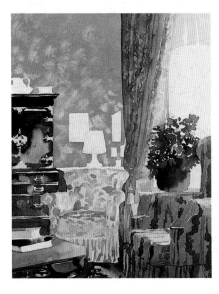

△9 *Smaller objects are added, wet on dry. Here the artist paints a picture frame in dark grey, taking care that the tones blend with those already established elsewhere in the painting.*

▷10 *The completed picture looks far more complicated than it really is. Viewed from close quarters, there is very little real detail in the painting. Yet seen as a whole, it looks remarkably realistic, with blobs of runny colours creating an illusion of printed fabrics and flowers.*

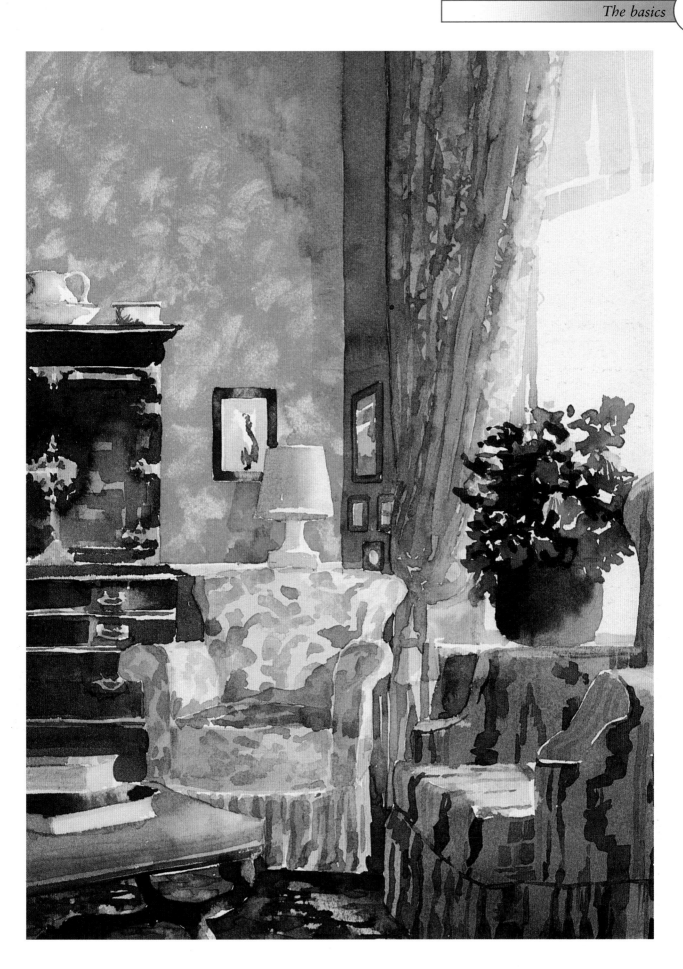

Basics plus . . .

ONE OF THE most encouraging aspects of watercolour painting is that most of the techniques can be learned and, once learned, they can thereafter be improved with practice.

It is comforting to realize that while some artists are indisputably more able than others, their ability often lies in a particular direction. A great number of eminent artists have had to work extremely hard to correct a particular weakness or bridge a gap in their artistic abilities. For instance, one painter may be a natural colourist but weak on drawing, while another will be good at drawing but have a poor sense of tone, and so on.

The classical approach to watercolour is to work from light to dark. This is the logical way to work when painting with transparent watercolours, and once understood and mastered, the technique will come easily and automatically.

Often, but by no means always, it is the colour of a particular subject which first attracts. Tones and colour temperature come later, when we start to paint. Again, recognizing and using these elements in your paintings are good professional habits which can be developed with practice, if you begin by consciously noting warms and cools.

Dark over light *This watercolour and mixed-media painting of a cathedral is built up with overlaid colour and dark outlines. The resulting empty white spaces play an important part in the composition, emphasizing both the loose, jagged style of the drawing and the patches of coloured wash.*

TECHNIQUES

DARK OVER LIGHT

Painting in watercolours calls for a particular way of thinking – a sort of planning in reverse. The paint is transparent, so you cannot cover anything up once it has been painted. This is one of the most difficult concepts to grasp when you embark upon watercolours.

Perhaps many people are confused at first because they began, from school age, with powder paints, which are opaque. As with oil paints, you may have become used to covering up and hiding parts of the painting with new layers. Painting a

Building up layers *This landscape shows four distinct stages of watercolour, working from light to dark.*

▽**1** *The first is pale washes, representing the palest areas. Highlights are left as patches of white paper.*

highlight, or reflection, with opaque paints is a relatively simple matter of blobbing on some white paint. But with transparent watercolours, you cannot do this. You must know from the outset where the highlights are going to be, and leave these as patches of white paper. However, once you have grasped this basic principle, the back-to-front approach will become automatic.

The principle means always working from light to dark. You have to think in advance where the lightest areas are and paint those first.

White as a last resort
One of the great charms of watercolour lies in its transparency, and if you have to use a lot of white paint to re-establish highlights and pale areas that have become lost in the painting, you inevitably lose the transparent quality of the medium. Those with traditional, purist attitudes to watercolour painting tend to frown on the use of white paint or any other opaque white for this reason. Taken literally, this means that if you forget to leave the light areas light and the white areas white then you are stuck with the mistake and cannot correct it.

▽**2** *At this stage, the artist knows exactly where the pale areas will be in the final painting and avoids touching these when applying medium tones which include certain shadows and darker stonework areas.*

Adding water

Ideally, you should not have to use white paint at all. Pale and pastel colours are mixed by simply adding more and more water. Thus pink is diluted red, light green is diluted green, and so on. Mixed in this way, the colours remain transparent, whereas added white makes them opaque and chalky.

Obviously a rigid attitude is counterproductive, and in reality even the most experienced watercolour painters occasionally resort to touching up and masking out with white. But too much white does detract from the quality of the painting and you should aim to use it as little as possible.

Broadly speaking, the procedure is this. You should work out where the white areas and highlights are and leave these as patches of white paper. Next, apply the very lightest tones across the rest of the painting. Paint the medium tones into the light tones, and finally add the darkest tones.

▽3 Next, selected deep tones are laid and allowed to dry. Again, the pales and mediums are left untouched as the artist paints in some of the deeper shadows.

▽4 Finally, the artist simultaneously adds the darkest areas to every part of the picture, bringing together the separate elements – the stonework, grass, trees and road. Any colour or tone that is too light or too dark in relation to its neighbour is corrected at this stage.

TECHNIQUES

WARM AND COOL

The idea that colour has a temperature, and that every colour is either warm or cool, might seem irrelevant to the painter who is concerned only with painting what is there. But in fact colour temperature is very important, because everything we look at contains a balance of warms and cools, and it is this balance that makes a subject interesting or otherwise. And if the balance is lacking, then it is often up to the artist to put this right.

For example, a still life of fruit on a wooden table against a cream wall might seem dull because these colours are predominantly 'warm'. At first sight, the subject seems to lack interest – the contrast that would be provided by the 'cool' colours such as blue, green and violet.

However, an artist will always find contrasting temperatures in any subject, and these are the colours that give the painting zest and bite. Look at the shadows on a piece of yellow, red or orange fruit. Shadows are never grey or completely without colour. They will inevitably contain traces of blue, green or violet. A flat cream wall is rarely completely flat because the light will come from one side. This side will be warmer than the barely discernible shady side, which will possibly contain traces of mauve, pale green or another cool colour.

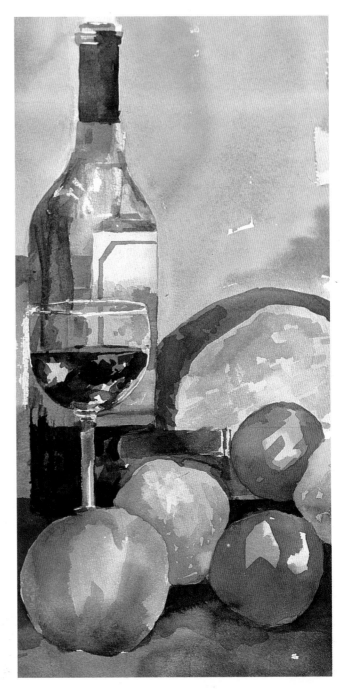

▷**Warms** *Reds, oranges and warm browns are the dominant colours in this still life. A painting done in warm colours alone can look monotonous and usually needs a few contrasting cools to bring the image to life. For this reason, the artist has introduced cool greys and blues into certain shadow areas.*

Finding a balance

The subject is what you, the artist, make it. You are free to use a predominance of either warm or cool colours without changing the character of the subject, just as you are free to exaggerate the warms and cools for the sake of the painting. Take a look at many of the artists of the past, particularly the Impressionists and the Post-Impressionists. You will see just how much artistic licence was often taken, particularly with flesh tones. Notice how the cool shadows of faces and figures were often depicted as quite violent blues, violets and greens and how the illuminated tones were frequently portrayed as bright pink, peach, yellow and orange.

We have seen that the warm colours are reds, oranges and yellows, all grouped together on one half of the colour wheel, and on the opposite side of the wheel are the cool blues, greens and violets.

Obviously, there are lots of different reds, many different yellows, and so on, and it is worth remembering that the temperature of each colour varies even within its own colour group. A golden yellow is very warm, whereas a lemon yellow is cooler; alizarin crimson contains a lot of blue and is cooler than a bright orangy red such as cadmium.

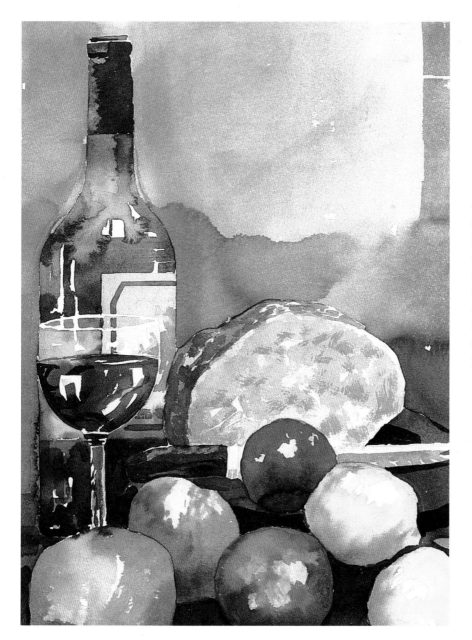

◁**Cool** *Without the added contrast of a few warm tones, an image painted only in cool colours lacks resonance. In this painting, the overall colour scheme is dominated by cool greys, which the artist has counteracted with splashes of red, orange and yellow.*

PROJECTS

NARCISSI

Light to dark

When watercolour is painted directly on to white paper the white glows through, making the colours much brighter than they would be if they were painted over another colour. Even the palest tinted paper can destroy this characteristic glow, and this is why true watercolour supports are always white or nearly white.

The translucent petals and leaves of flowers, a traditional favourite with watercolour artists, make them the perfect subject for the vivid and shimmering effect of transparent paint over a bright-white paper.

The background

The artist wanted a dark background yet with bright flowers and leaves, so a background wash was painted around the shape of the subject, leaving the white paper on which to paint the flowers and vase later.

When painting around a subject like this, you must work quickly to prevent the colour drying in

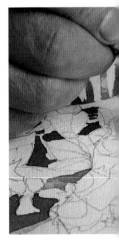

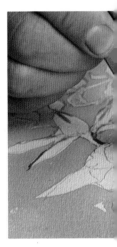

△2 *Because the artist worked quickly when he was laying the background, the colouring is reasonably even. The grey wash is taken right up to the drawn outline, leaving the flowers and vase as a white shape ready to receive colour.*

obvious tide-marks. Keep the paint moving as you go around the outline. The colour probably won't dry completely flat, but this does not usually matter.

Flowers and leaves

Two basic techniques are employed: wet on dry, to establish the delicate but crisp shapes of the leaves, stems and petals, and wet on wet, for the softer patches of colour within the flowers themselves.

All the colours are painted from light to dark, in the classical watercolour manner. The palest greens of the foliage and the lightest yellow of the narcissi are blocked in first, and then the image is built up gradually from light to dark.

Most of the work is done with a Number 6 round brush. The artist likes to simplify life by using as few brushes as possible and finds a medium-sized round is the most flexible. Its size is good for painting large areas, and the bristles can be shaped into a point and used for fine, linear work.

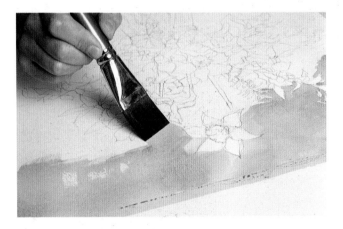

△1 *This flower subject was painted from a palette of cerulean, cobalt blue, burnt umber, raw umber, cadmium red, lemon yellow, viridian and Payne's grey. The artist starts with a light pencil drawing, and then blocks in the background with a wash mixed from Payne's grey and a little cerulean.*

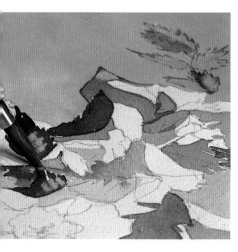

◁3 The light foliage tones are painted in a mixture of cobalt blue, Payne's grey and lemon; medium tones are the same colour with added Payne's grey and a little cadmium red. Using variations of the basic colour mixtures, the artist continues to block in and develop the leaves and stems. Darker shapes in the foliage are created by overlaying various tones of green. Colour is allowed to dry between stages, and subsequent paint is applied wet on dry.

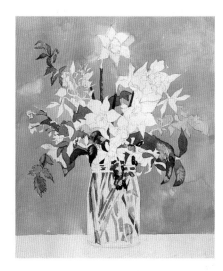

▷4 Except for a few very dark areas, the greens are now virtually complete – the lightest, a pale greenish yellow; the darkest, almost grey. Note how the artist has simplifed a complex mass of foliage and stems into three or four basic colours, choosing the appropriate one for each area.

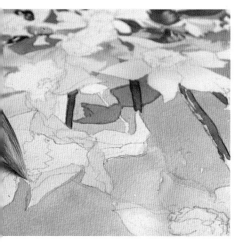

◁5 The narcissi are blocked in with a pale wash of diluted lemon yellow mixed with a touch of Payne's grey.

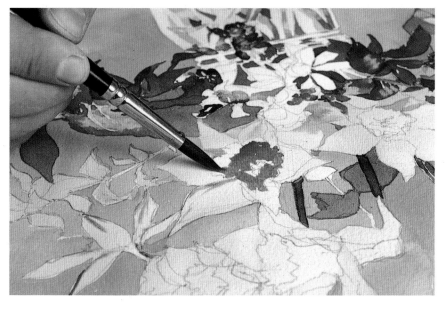

◁6 When the yellow is completely dry, the bright-orange centres are blocked in with a mixture of lemon yellow and cadmium red.

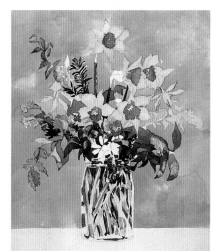

▷7 So far most of the subject has been established. Certain areas, such as the leaves, are nearly complete; other parts, including the narcissi and blue flowers, have been blocked in and await development.

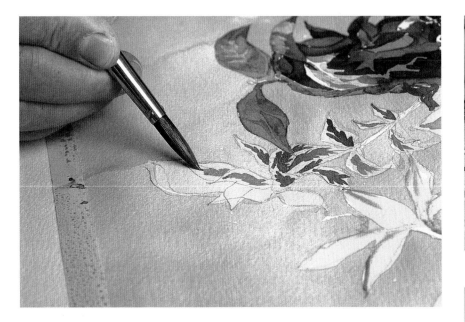

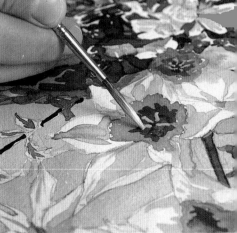

△8 Before proceeding further with the flowers, the artist adds some final dark tones to the foliage. Here, the deep-green shapes on the variegated leaves are being defined.

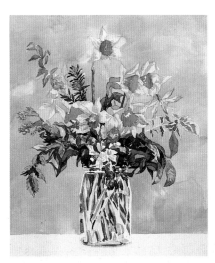

▷9 Working from light to dark, in the classical watercolour manner, the artist has developed the darker tones of the flowers; grey shadows are painted on to the yellow petals of the narcissi, and deep shadows worked into the smaller blue flowers.

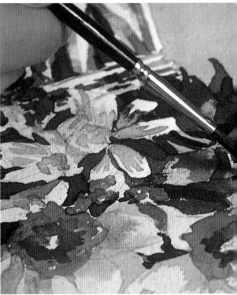

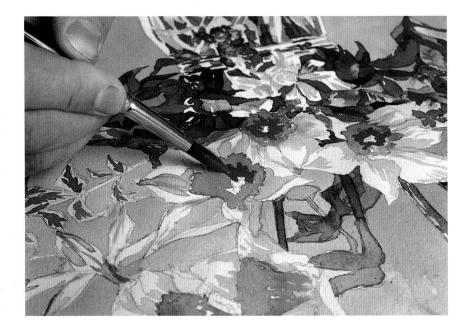

▷10 Dark-orange shadows help to describe the trumpet forms of the narcissi centres. This is mixed from the former orange with added cadmium red.

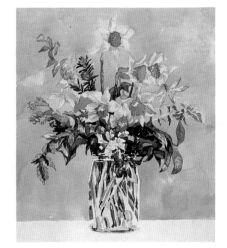

◁ **12** *The flower centres are much paler than their orange backgrounds, so the artist adds Chinese white with a little of the orange flower mixture to produce a pale, opaque colour. The point of the brush is used to apply these details to the centre of each narcissus.*

△ **13** *The flowers and foliage are now complete, and the painting is almost finished. Even at this late stage, the absence of any background shadow makes the painting look rather flat.*

△ **11** *The painting is almost complete, and the artist allows the colours to dry before adding the finishing touches.*

▷ **14** *Finally, the strong background shadow of the vase and its contents is blocked in. This shadow defines the depth of space behind the subject, so bringing the subject to life by placing it in three-dimensional space.*

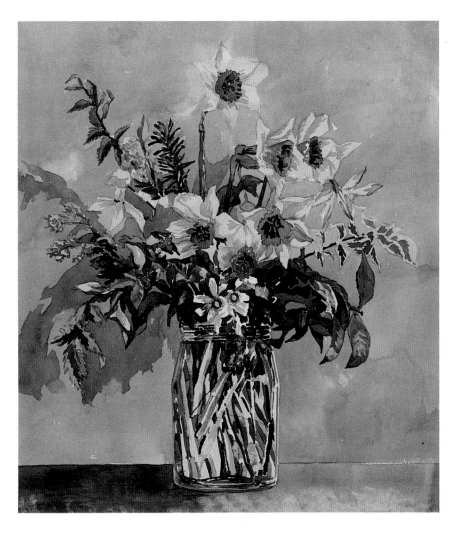

67

Texture and landscape

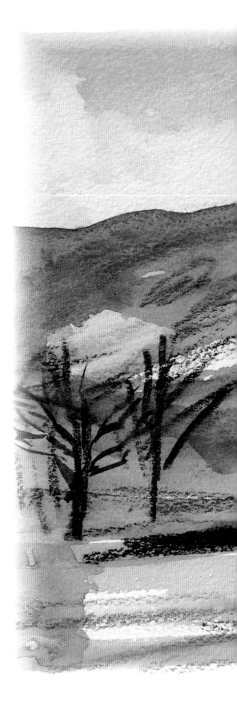

THE WORLD and its landscapes are made up of textures and patterns so familar that we often don't notice them until we try to paint them. The notion that flickering light, crumbling concrete, dry stone, foliage, bark, reflective water surfaces and a million other diverse effects can be captured with mere paint and paintbrush seems remarkable. But it can be done.

For the watercolourist, the secret is to simplify. Look at what is in front of you and think how a similar effect can be created with the tools available. The following pages give a few ideas; the rest is a question of experiment.

Most watercolour textures have a literal use, but they can also be applied imaginatively to less obvious subjects. Spattering, for example, as the artist demonstrates on page 95, can also be used to give the impression of shingle, sand, pebbledash and even wild flowers in a field. Random runs of colour that often happen accidentally look exactly like marble and can be used as such, but a two-tone mottled texture can also represent the reflections of a wet surface or the flickering lights and darks of leaves moving in the breeze.

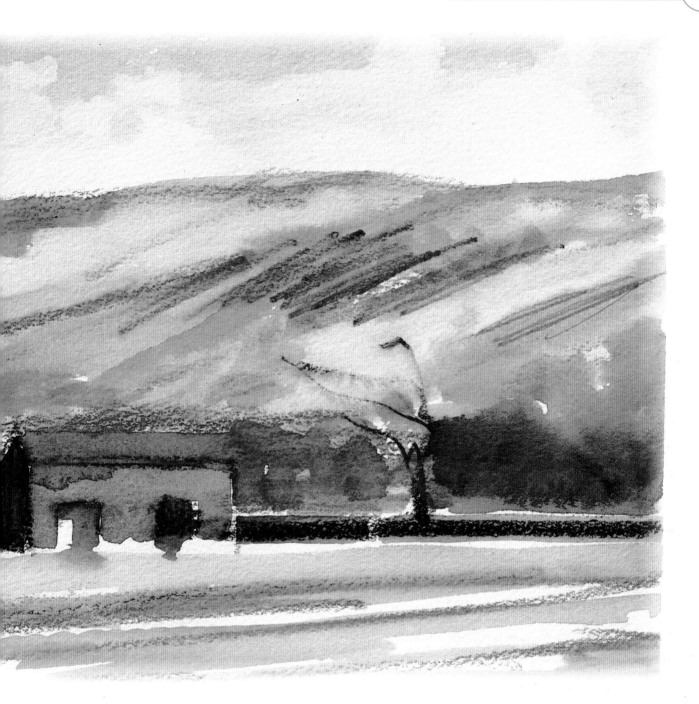

Watercolour and wax *Strong directional brushstrokes are combined with pastel and wax crayon to create this bleak, windswept landscape. Much of the texture is the result of the wax crayon resisting the paint.*

TECHNIQUES

TEXTURE MAKING

Apart from the tide-marks and colour variations that can occur spontaneously, there is remarkably little texture in many watercolours. Unlike oil paintings, which often have a rugged surface made with thickly applied paint, watercolour has little actual surface texture. Generally, this does not matter because we choose watercolour for its other qualities – its glowing colour, its transparency and the beautiful and accidental effects of painting wet on wet.

Occasionally, however, you might want to introduce a few textural effects into your picture, either to depict a pattern or texture in the actual subject, or to enliven the picture surface, and it is useful to have a few tricks at your fingertips.

A porous brick wall, a rendered building, a pebble beach – all these have surfaces that are difficult to portray in washes of watercolour. They call for special treatments, for surface textures that will give an impression of the real surfaces.

Creative texturing

The secret of successful texture-making is to be selective. It is how and where you use the technique

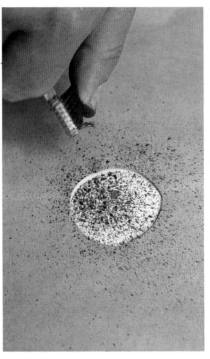

Wax crayon

△**1** *Draw on to the paper with wax crayon. Use either the tip or broad side of the crayon, depending on the texture you want.*

▷**2** *When watercolour is applied over the drawing, the wax resists the paint and the textured drawing shows through the colour.*

Spatter painting

△**1** *Dip the tips of a toothbrush into the mixed paint. Hold the brush above the paper and spatter the colour by pulling your finger backwards across the bristles.*

▷**2** *Spattering can be built up in layers, and there is no real limit to the amount of colours you use.*

in the painting that are important, rather than how accomplished you are at the technique itself. For instance, it is not difficult to get a speckled effect by spattering the paint. However, the ability to apply the spattering as the artist does in the painting of a rough sea on page 95, aimed at achieving exactly the effect of foaming sea spray, requires both imagination and considerable restraint.

Wax 'resist' is good for breaking up and adding interest to large areas of colour. This effect relies on the principle that water and wax do not mix. So, if you paint over marks made with wax crayons or even a domestic candle, the wax will resist the wet paint and show through the colour. You can make lines with the wax or, alternatively, you can create areas of texture by scribbling or by using the broad side of the crayon or candle. Note that the colour of

the wax crayon will show through the paint, whereas if you use a white wax candle, it is the colour of the paper underneath the paint that shows through.

Another time-honoured technique, popular with many of the early watercolourists, is 'drybrush'. Here, the artist squeezes most of the wet colour out of the bristles before dragging the semi-dry brush across the surface of the paper. The starved bristles catch on the rough surface of the paper, producing a broken, scratchy effect through which the white paper is clearly visible. The coarser the paper, the more effective the texture.

Dry brush

◁1 *Dip the tips of a dry or almost-dry brush in the colour. Spread the bristles with your thumb, then drag the brush across the paper.*

▽2 *Depending on the texture required, dry brush can be applied criss-cross or in short, directional strokes. You can also use two or more colours on top of each other.*

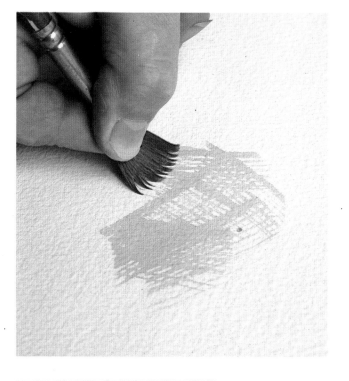

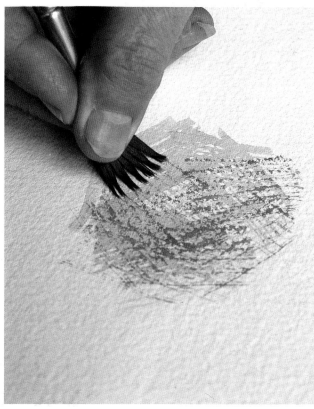

TECHNIQUES

CREATING WHITE

All white paints are opaque, and if you mix white with any other watercolour you will get a pale but chalky colour which is not transparent. Traditionalists do not approve of the addition of white paint to watercolours for this very reason, because it interferes with the transparency of the colours. But there is a lot of white in any subject – if you were painting with oils or acrylics, for instance, you would use more white than any other colour – so whites have to be created in some other way.

We have already seen how the whiteness of the paper can be used instead of white paint, both for white areas and highlights, and to create pale colours. But there will inevitably be times when you will want to add white in the later stages of a painting, either to correct a mistake or because you want to sharpen the shapes or to add details.

There are various ways of introducing white into a watercolour painting. For small areas you can use white paint. The classic watercolour pigment is Chinese white, and this is the one to use if you really have to mix a pale colour in order to cover another colour. It can also be used for touching up and spotting out smudges and mistakes. White gouache is more opaque and very good for touching

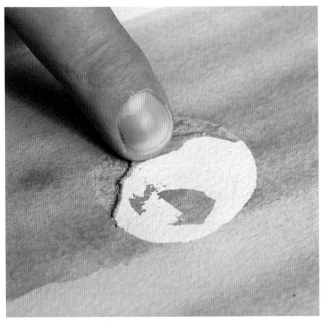

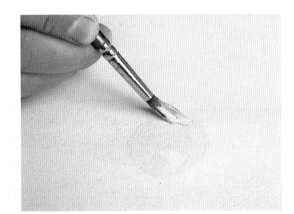

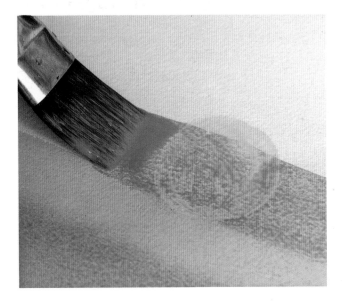

Masking fluid
◁ △1 *Paint the masking fluid over the areas you want to remain white (use an old brush, because the rubbery solution can ruin the bristles).*

◁2 *Allow the masking fluid to dry thoroughly, then apply colour over the masked area.*

△3 *When the paint has dried, remove the masking fluid by rubbing with your finger or a clean eraser.*

up, but it should never be mixed with watercolour to create a lighter tone of a colour because this really does deaden the quality of the paint.

Masking fluid

If you know from the outset that you want hard shapes of white in the final painting, then masking fluid is perhaps the best way of achieving this, because it protects the paper however much colour you paint over it. The dried fluid is easily removed when the final paint is dry. Masking fluid takes a little getting used to. It leaves a very stark shape when it is removed. You may have been painting the rest of the picture, carefully gauging the tones, and then be surprised at the glaring whiteness when you rub away the masked areas. Also, masking fluid is better on smaller than larger areas.

Other techniques

Otherwise, cotton buds or tissue can be used to soak up wet colour to give you patches of white with blurred edges – useful for soft textures and marbled or mottled effects. Another way is to paint household bleach on to an area of dried paint, but pigments with a particularly strong staining power resist the bleach and become paler rather than disappearing. To make white lines and sharper textures, you can scratch through dried paint with a scalpel or other sharp instrument to reveal the white paper underneath.

Blotting

◁**1** *Wet colour can be absorbed with a cotton bud or by dabbing with tissue.*

▽**2** *The resulting patches will be white or pale depending on the strength of the colour you are blotting.*

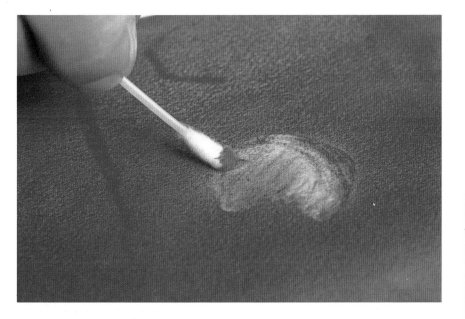

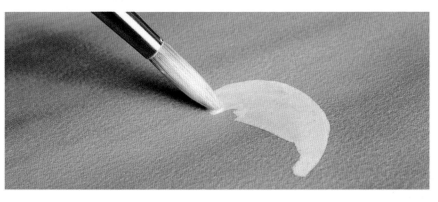

White paint

△**1** *For touching up small areas, the best way to create white is to use paint. Gouache, poster colour,* process white and Chinese white watercolour are all suitable, although the watercolour white is less opaque than the others.

△**2** *One coat of white is generally sufficient to cover a pale colour; otherwise you may need a second application.*

TECHNIQUES

PAINTING LANDSCAPE

Landscape is the most popular subject of all with watercolour artists, and it is often the desire to paint beautiful scenery that entices many into trying watercolours for the first time. Sadly, a good number give up after one or two failures, usually because they have been too ambitious and have tried to include too much in their early paintings.

Every leaf?

One good first guideline to landscape painting is not to be too literal. You cannot paint every flower, leaf, pebble or blade of grass. You have to generalize, to aim for an approximation of what you see, rather than try to paint everything. Do this by half-closing your eyes so that the subject becomes blurred and is reduced to hazy areas of tone and colour. This eliminates much of the detail, freeing you to concentrate on simplified areas which must relate correctly to each other.

A second guideline is to paint what you see to be there rather than what you believe to be there. For instance, when you partially close your eyes, look at the difference in tone between the sky and the land. It is almost always less than you think, and in certain weather conditions the sky is actually

▷**Trees** *No two trees are the same, yet the landscape painter must find a way of generalizing without sacrificing the individual characteristics of each tree. In this painting, artist Sally Michel has used pale washes for the background foliage, and simplified the foreground trees and conifers into two or three main tones.*

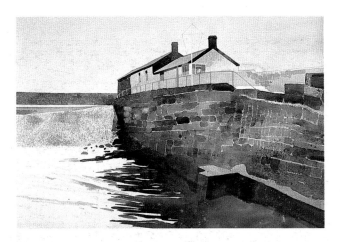

△**Quayside** *The strong arrangement of angular shapes in this composition encouraged the artist to treat each of these main areas in a different way. Spattered paint represents the shingle of the sea wall; the harbour wall is painted in overlaid, rectangular brushstrokes; and the reflections are a pattern of sharp slivers of colour.*

darker than the land. This relationship between the sky and the rest of the subject is crucially important and is the first thing to establish in your painting. So, start with the sky, and then lay the lightest tones of the landscape, which will normally include the far distance and the horizon.

Ways of learning

A loose, general approach is best for all types of landscape, but this does not mean all landscapes have to be painted to the same formula. A good way to discover some of the possibilities is to have three paintings on the go at the same time, each slightly different. Find a view that you like and do, say, a broad panorama of the whole thing. You can also try a close-up of a small part of the same view, so that you have to confront a certain amount of

detail, but still paint it in the same general way. A third painting could be extremely loose, using very strong colour and big brushes. The point of the third is that watercolour tends to dry pale, and by exaggerating the colour you ensure a bright, vibrant finished painting.

Watercolours dry slowly, especially on a sunless day outdoors with no hairdryer available to speed up the process. By doing three paintings concurrently, you can often work three times as quickly, leaving a painting to dry while moving on to the next.

△**Seascape** *This seascape was painted and enlarged from a very tiny sketchbook drawing, and as a result it contains little detail. The water is painted in loose, fluid washes; clouds and smoke from a distant fire are depicted as a series of flat coloured shapes, rather like overlaid jigsaw pieces.*

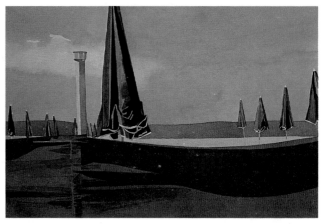

△**Beach scene** *The horizontal red windbreaker and upright shapes of the red and green umbrellas make this a most effective and unusual composition. Its success lies in its absolute simplicity and in the creative use of the complementary colours red and green.*

PROJECTS

SKY AND CLOUDS

Look carefully at a bright blue sky, and you will see that the colour is not flat and even but varies considerably, getting lighter as it goes down towards the horizon. You can test this by holding a sheet of white paper up to a cluster of white clouds; you will realize that the clouds are not actually white at all; but are a blurred mass of light greys, yellows and other pale colours.

A cloud with the sun directly behind it has a stark, sharply defined edge, but otherwise clouds are soft and amorphous without any clear shape. They have depth and density but no outline.

Graded colour

For the watercolour artist, this makes skies and clouds very paintable indeed, because working wet on wet naturally produces effects which capture exactly the graded colour of a clear summer sky or the soft, voluminous quality of cloud formations. Night skies are obviously darker, and the light comes from the moon instead of the sun, but the approach is exactly the same. Again, the sky becomes lighter towards the horizon, which at night is often tinted with the orange background glow of neighbouring cities.

Soft outlines

Every sky is different, so look carefully before starting to paint. Although clouds are generally undefined, some are clearer than others. Remember, the wetter the paper, the less definition you will get. Once you have applied the broad shapes, allow the colours to find their own shape on the damp paper.

Overcast sky

▷1 *An overcast sky can be painted using just Payne's grey and water. Start by applying the diluted paint. Allow the grey to form dark blotches in some areas, and leave occasional patches of white paper in others.*

You can spoil the effect by overworking. If you prefer working on to a dry support, an alternative method is to apply colour and then quickly soften the hard shapes with clean water before the paint dries.

The best skies are painted very quickly. The more you work them, the less convincing they become. Big brushes and spontaneous strokes of colour are more appropriate than meticulous rendering.

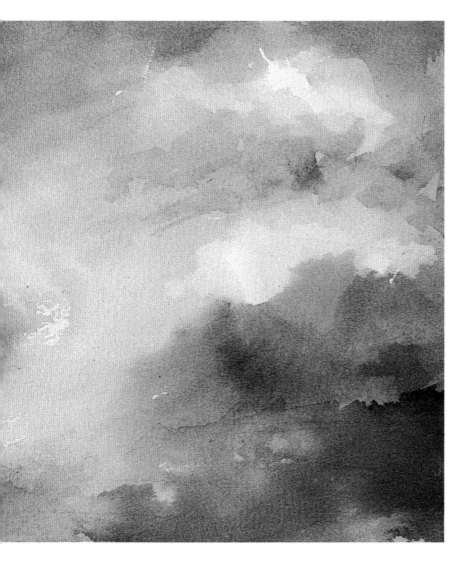

◁4 *Do* not *overwork the paint. With landscape pictures, it is usually best to paint the sky first. Other colours and tones can then be related to this important element.*

◁2 *Soften the brushmarks and any hard edges by dabbing with a tissue.*

▷3 *While the paint is still wet, work more colour into the dark areas and soften the edges by blotting with a tissue.*

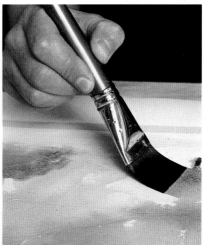

Cloudy sky

▷**1** *The sky is painted with a mixture of cerulean and cobalt blue, applied with a large, round brush. Paint loosely and quickly, without going back to tidy up the shapes.*

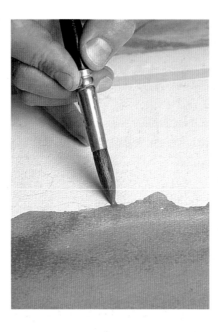

▽**2** *Load the brush with clean water and flood the edges of the wet blue to soften the shape.*

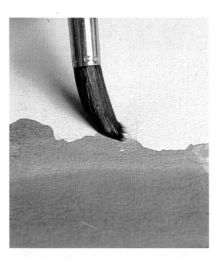

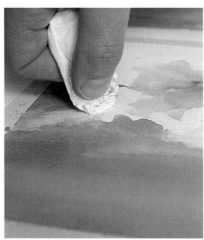

△**3** *Work into the white clouds with diluted Payne's grey, allowing the colour to form soft, irregular shapes. Use a tissue to soften the strokes and remove excess colour.*

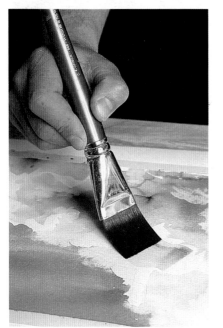

◁**4** *Apply more of the diluted Payne's grey, concentrating on the underside of the clouds. Again, excess paint can be softened by blotting with a tissue.*

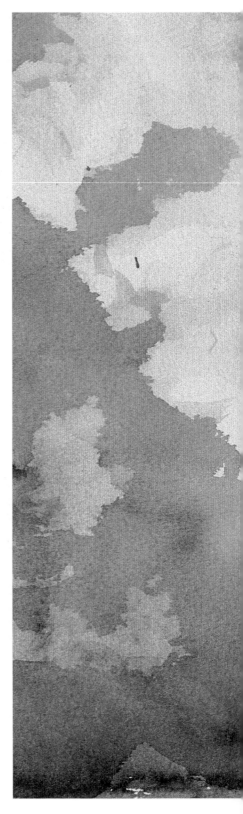

△ 5 *By varying colours and shapes,*
you can apply this basic formula to
any type of sky, including night
skies. On no account try to rework
or improve on the finished sky.

TREES IN SUMMER AND WINTER

Masses of foliage and tiny branches look daunting, but if you use a big brush and ignore the thousands of leaves and tiny branches, trees are no more difficult to paint than anything else. If you half-close your eyes, this will help block out these details, and you will see only main areas of light and dark colour.

Trees with foliage

Don't make trees too green. Greens in nature usually contain a lot of ochres, blues and yellows, so it is generally better to mix some of the greens from these colours rather than to start with a pre-mixed green that is too bright for the subject. Autumn colours are easier because they are generally a mixture of warm rusts, browns, yellows and pinks.

Start by painting the blocks of light tones very broadly, working mid and dark tones into this while the colour is still damp. Unless you are painting certain evergreens with a fairly dense form, trees are rarely solid but have patches of sky or background colour between the blocks of foliage.

The trunk is often similar in tone and colour to the foliage. Trunks usually have a green or grey appearance, so avoid the common mistake of painting them a conspicuous dark brown. A trunk in the shadow of the leaves is often dark and nearly invisible, and can be seen only where the light falls on it.

Trees in winter

In winter, deciduous trees become leafless skeletons of twigs and branches and your approach will obviously be different. Work on to dry background colour and choose your brushes carefully. Here, the

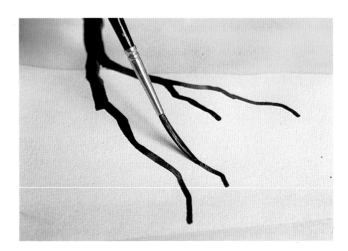

Winter trees

△1 *The artist started by painting the background in simple washes of blue and green and allowed these to dry. When painting winter trees against a coloured background, always start with the background – it is virtually impossible to add this once the trees are painted. The tree trunk is painted with a flat brush, the smaller branches added with a round and a rigger.*

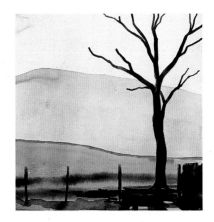

△2 *The tree trunk and larger branches are now established. When painting and drawing trees it is important to remember that the trunk, branches and twigs taper as they grow – in other words, all the shapes get thinner.*

artist uses a flat brush for the trunk, a medium-sized round for the branches and a rigger for the small, tapering branches.

Winter trees often look like silhouettes, but they never appear completely flat. They are three-dimensional. Branches radiate at different angles. The trunk and larger branches contain different tones, often with highlights and reflections.

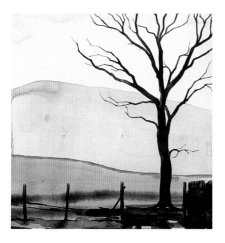

△3 *Smaller branches have been painted with a rigger, the long, thin bristles allowing the artist to taper each twig to a point.*

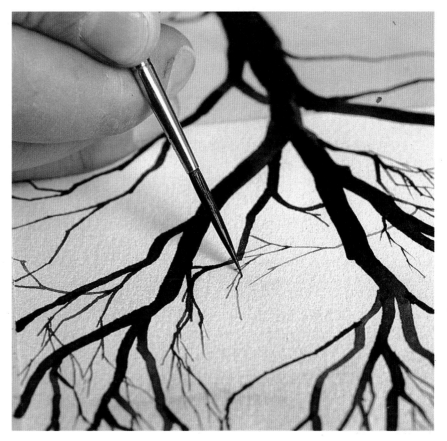

△4 *Still working with the rigger, the artist adds the finest twigs. These are painted in a diluted version of the main tree colour and, again, each twig dwindles to a point and fades out.*

◁5 *A tree is usually painted in context – in this case, it is part of a simple landscape. Notice how the tone of the tree relates to the darker areas of its surroundings, thus avoiding the common mistake of making trees too prominent.*

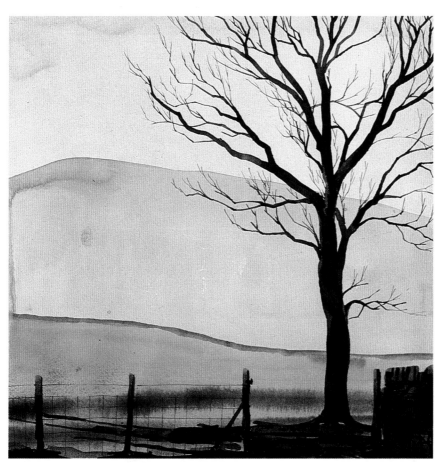

Trees with foliage

△1 *Before starting to paint, the artist makes a simple pencil drawing, plotting the position and outline of the main shapes. Wax crayon is then applied to selected areas. The crayon resists subsequent overpainting, adding a textural variety into the finished painting.*

▷ 2 *Various shades of Hooker's green are applied to the main tree shapes. The artist takes the colour washes right up to the edge of the light blue sky.*

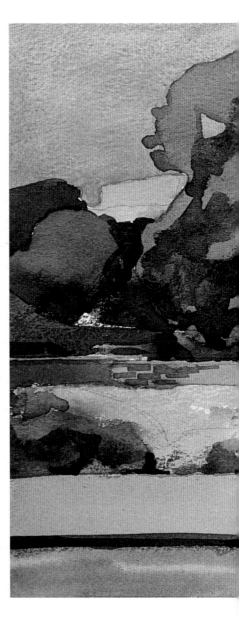

△3 *Grass and the first pale foliage colours are blocked in as flat shapes. The greens in the paintings are mixed mainly from viridian and Hooker's green – dark and light. A touch of cerulean blue is added to make the blue-greens, and cadmium orange for the warmer greens.*

◁ 4 *Here the artist uses wax crayon on top of the flat, dry watercolour to create a foliage-like texture.*

▷5 *Finally, the dark tones are painted into the pale tree shapes. Here, the underside of one of the main trees is applied wet on dry.*

▽6 *Although green is the dominant colour here, the mixtures are varied enough to make the subject interesting. The wax crayon shows through in certain places, interrupting washes of watercolour with patches of broken texture.*

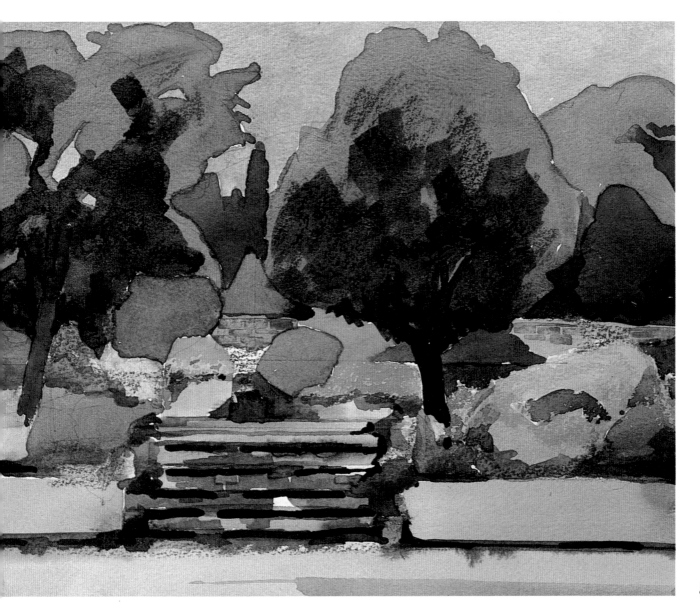

<div style="text-align: center;">PROJECTS</div>

TULIP FIELDS

Landscape

Sky, water and tree – some of the main elements of the rural landscape – are brought together in this picture.

The scene is simple and undramatic, apart from the striking tulip fields, which stretch out as far as the eye can see. As they converge and vanish at an imaginary point on the horizon, these colourful stripes create a sense of vast space. To emphasize this vanishing-point, the artist breaks one of the rules of composition and puts the horizon almost exactly halfway up the picture, splitting the composition into two equal shapes.

Composition

The blue sky which dominates the top half of the picture is reflected in the canal at the lower edge. This repetition of the same colour 'unites' what would otherwise be two completely separate shapes. The diagonal placing of the canal also helps to break up the symmetry of the picture, and make it more interesting.

However simple or complex the subject, composition is important. With a landscape you have to decide which part of a scene you want to paint, how much sky to include, where the horizon should be, and so on. With a simple subject, composition can be even more important.

A single object, such as an apple or a plant, must be placed in a three-dimensional space, otherwise the object itself will not look three-dimensional. It cannot be left to float in the centre of the paper; it must be placed in context. Thus, if the object is on a table, the far edge of the table becomes the horizon; a division in the background, such as a corner, divides the background vertically and – as with this landscape – you have a composition that is divided into three shapes.

◁1 *The blue sky is painted in a mixture of cobalt blue and cerulean, and the edges softened with water.*

▷2 *The artist sponges into the clouds with a washy Payne's grey, concentrating on the shaded undersides and allowing the colour to settle unevenly.*

Variety of brushes

To paint the different elements, the artist uses a variety of brushes: a large round for the sky and clouds, a flat for the broad lines of the fields and both of them for the tree in the foreground, with the addition of a rigger for the smaller branches.

▽3 *Sky and clouds are blended at the edges with a wet cotton bud.*

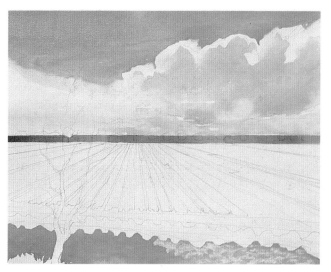

△4 *The blue mixture is used to block in the sky reflection; the dark background green is mixed from cerulean, cobalt blue, cadmium yellow and Payne's grey.*

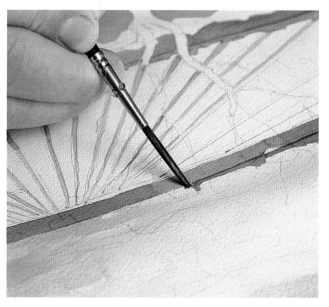

△5 *Working into the painting, the artist mixes cerulean, yellow ochre and Payne's grey for the sky, and paints the distant horizon with diluted Payne's grey.*

85

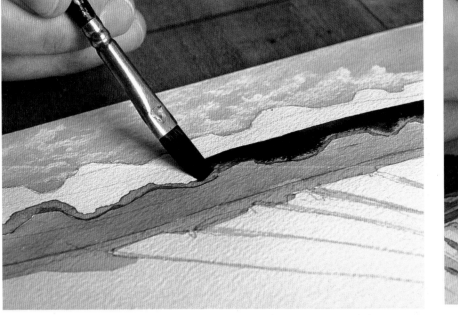

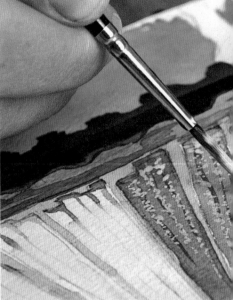

△6 A strip of foreground grass is painted in Hooker's green dark, lemon yellow and yellow ochre. An adjoining strip of Payne's grey, depicting the canal bank, is allowed to run into the wet green.

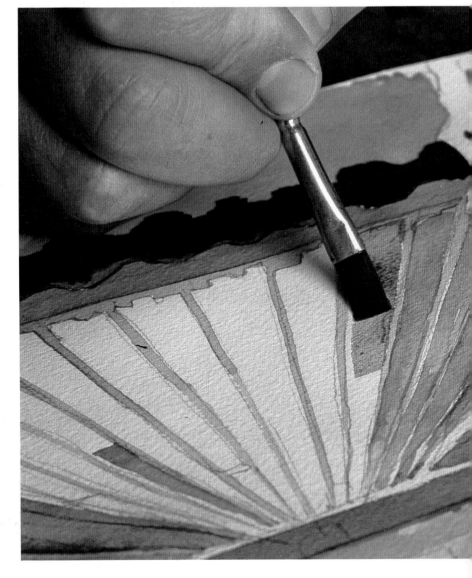

▷7 Rows of tulips are blocked in as strips of thin colour. The artist uses a rigger for the fine lines and a flat brush to paint the broader strips. A tree on the canal bank is left as a white silhouette.

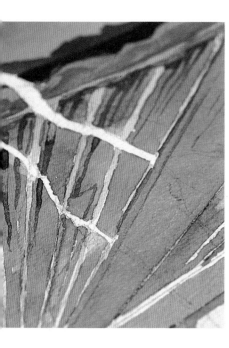

◁8 *Here the artist uses Chinese white to dot in the white tulips, using the paint thickly enough to cover the darker green of the underlying foliage.*

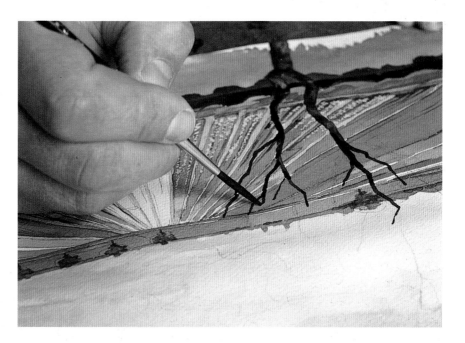

△9 *Finally, the tree is painted in Payne's grey mixed with a little black. Note, the trunk and larger branches are painted unevenly to convey the impression of bark, and because the artist wants to avoid a flat, two-dimensional shape in this otherwise spatial composition.*

▽10 *In the final painting, the tree is an important focal point, a vertical shape in a predominantly horizontal composition.*

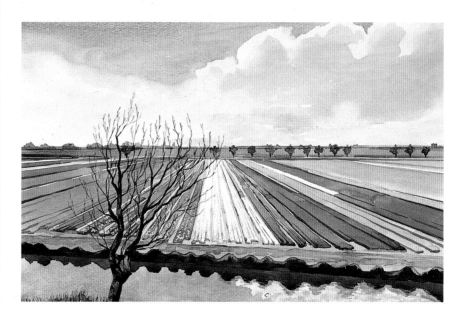

87

PROJECTS

WATER: REFLECTIONS

Water, of course, is fluid and this means it can generally be painted as such, by allowing the wet colours to flow and merge on the paper. Reflections, however, usually have quite definite shapes. They often have sharp edges, especially in bright sunlight, and these call for a different approach.

Reflected shapes

Water is seldom absolutely calm, so the reflections are constantly moving and changing, and this can make them quite difficult to see. It is much easier to paint water from a photograph because this gives you the opportunity to study and copy the characteristic shapes of light and colour that flicker fleetingly on the surface. However, there is a danger in this, especially if you make a habit of painting from photographs. The paintings can look rather static and tend to lack the freshness of work done by observation of the actual subject. Use photographs for general guidance, to find out how the surface of moving water looks at any given moment in time. Then put the pictures aside and concentrate on the real thing.

Either leave the highlights on the reflected shapes as patches of white paper or use masking fluid to block out the colour. Reflections often have one hard edge and one blurred edge, depending on the direction of the light, so eventually you will probably want to work back into the shapes with clean water to soften some of the edges.

Colour

Reflected colours are often as bright as the objects they reflect, but because they are broken by the movement on the water surface, they always look softer. The shape and colours of the reflections should correspond exactly to whatever is being reflected – a reflection from a tree, for instance, should be just as tree-like as the tree itself. A good way to test this is to turn your painting upside down – when seen from an unfamilar angle, it is always easier to spot mistakes and discrepancies.

◁1 *The artist starts with a light pencil drawing, sketching in the shape of the boat and indicating the movement of the water. Masking fluid is applied over those shapes which the artist wants to protect – namely, the emblem and side markings on the boat.*

◁2 *The extent of the composition is defined on the paper with strips of masking tape. This not only gives the finished painting a clean edge, but the artist also finds it helps to stop the paper from buckling.*

△3 *A very pale wash of cobalt blue is applied to the large reflected shapes on the water surface, and then allowed to dry.*

▽ **4** *Small, dark reflections from the boat are painted with a mixture of Payne's grey, Hooker's green dark and burnt umber. The bottom edge of each shape is very dark; the top half slightly lighter.*

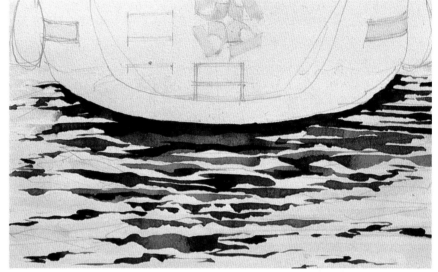

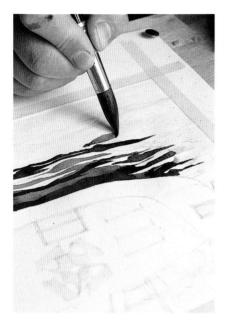

△ **5** *Reflected shapes flicker horizontally across the surface of the water and, characteristically, the closer they are to the object being reflected, the larger and denser the shapes become. Hence, the largest, darkest shape is directly beneath the boat.*

▽ **6** *The boat is painted in diluted Payne's grey, which the artist takes right across the masked areas.*

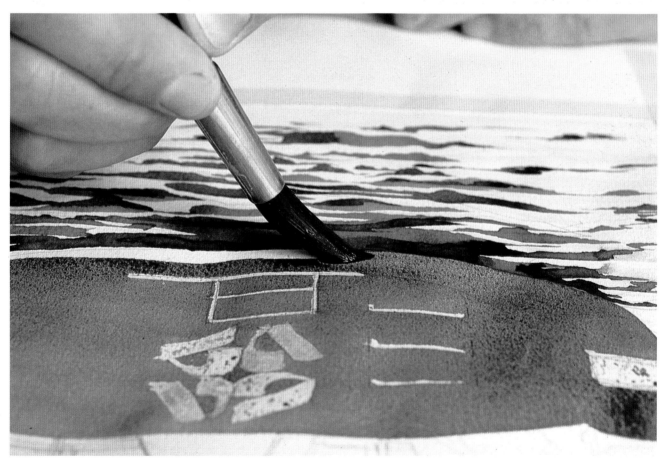

▽7 *Darker shades of grey are used to indicate the shadows underneath the bottom of the boat. Here the artist is removing excess colour.*

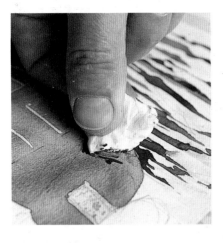

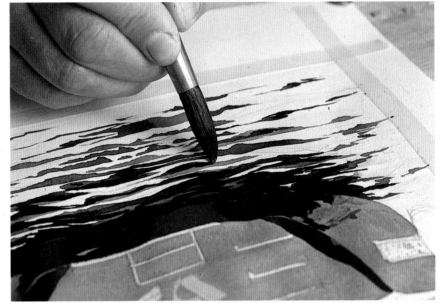

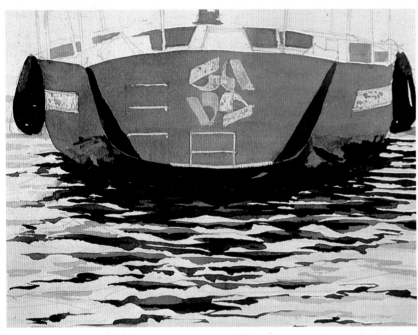

△8 *The darkest shadows on the boat have been added, and the artist repeats these in the reflection using the tip of the brush.*

◁9 *Continuing to develop the water surface, the artist has added tiny grey shapes of reflected sky around the broken outline of the boat reflection.*

▷10 *When the surrounding paint is completely dry, the masking fluid is removed by rubbing with the finger.*

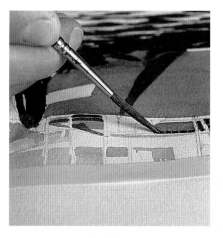

◁11 *Final touches are made to the boat and background, which is painted in pale washes of grey and other neutrals.*

▷12 *The artist paints the boat's emblem with a diluted mixture of alizarin and a little yellow ochre; the same colour is then introduced into the reflection.*

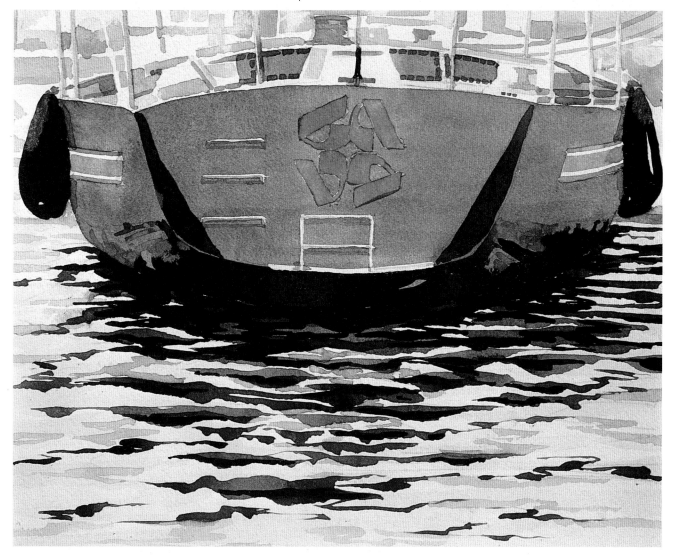

△13 *In the finished picture, the surface of the water is predominantly white with overlaid areas of pale blue. The reflected shapes are hard and sharp, painted in two tones to indicate the concave and convex forms on the water surface.*

PROJECTS

WATER: WAVES

Waves and other rapidly moving water surfaces are slightly trickier than calm water, but try not to be put off. Spend time studying the surface and look for repeated patterns to help give you a general impression. At first sight a wavy sea might look chaotic, but waves tend to repeat themselves in regular patterns and you may notice that every fourth or fifth wave is more or less the same shape. You may also find it helpful to make a few very rapid colour sketches to help establish the pattern in your mind.

Breaking waves

A breaking wave is formed as water is sucked back into a ridge which then becomes top-heavy and tumbles over. This gives each wave a cylindrical form, and if you can capture this by using light and dark tones, the waves will look much more realistic than if they were treated as flat shapes.

Unlike calm water, a rough sea does not take on the colour of the sky but is usually darker. The water is usually opaque, often muddy green or grey, made this way by the action of disturbed particles of sand and mud. The waves are topped with sprays of white froth as each one tumbles and breaks.

Spattered spray

White spray can be achieved with masking fluid, applied before you start to paint, or with white paint. Use gouache for a dense white or Chinese white for a slightly more transparent effect, spattering it with a toothbrush or small decorating brush.

Of course, no painting of water is going to be entirely accurate because the surface is moving all the time, with constantly changing shapes and tones that appear on the surface. So, unless you are painting from a photograph, which will freeze an instant in time and make all the shapes instantly visible, the shapes and colours will be approximate. But careful observation will help you create the essential characteristics of the types of water.

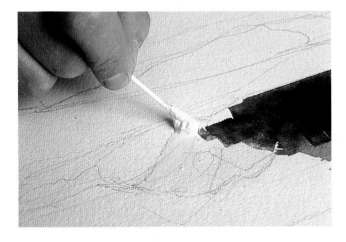

△1 *The artist begins by blocking in the rocks in a mixture of Payne's grey and black. Next, masking fluid is applied to all areas needing to be protected from the paint – in this case, the frothy tops of the waves, which will eventually be white. Masking fluid is applied with a cotton bud to approximate the chunky shapes of the froth and spray.*

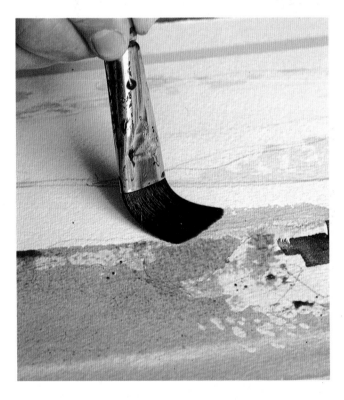

△2 *The sky is a thin wash of cerulean blue and Payne's grey; the sea is painted with a large, flat brush in a mixture of cerulean blue, Payne's grey and Hooker's green light. Colour is applied in horizontal stripes, some of which are deliberately pale and washy. The light streaks represent reflections on the water.*

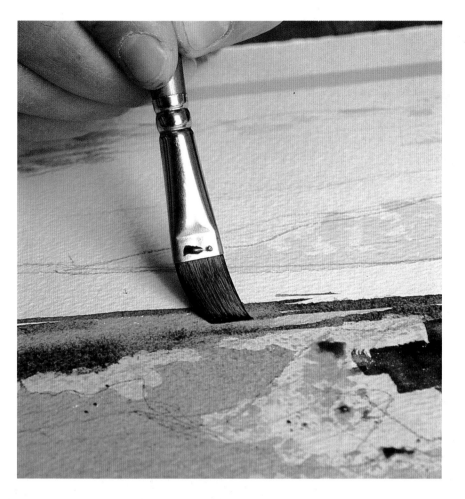

△3 *Dark streaks of horizontal shadow are applied in a mixture of French ultramarine, cerulean blue and Payne's grey.*

▽4 *Already, simply by applying strips of dark-blue shadow, the waves are taking shape. At this stage, the artist develops the rocks by adding areas of black shadow.*

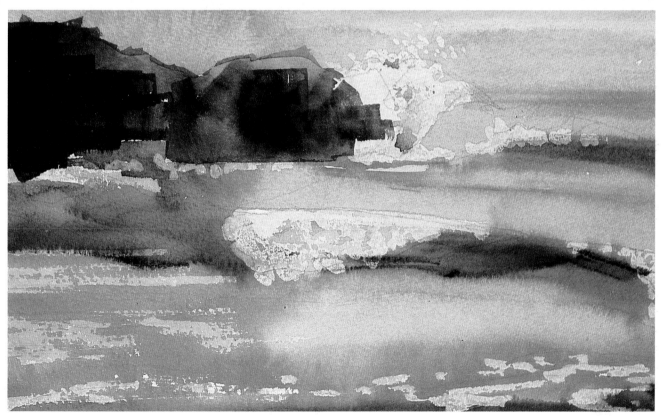

93

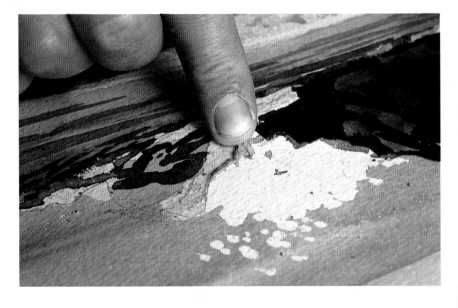

◁5 *When the paint is completely dry, the masking fluid is removed to reveal the white paper beneath.*

▷6 *The white shapes revealed by the removal of the masking fluid look flat and bright compared with the tones established elsewhere in the painting, but they are ready for further development.*

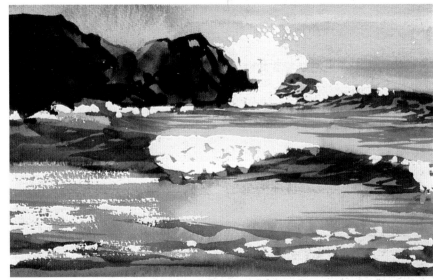

▽7 *Using a sponge, the artist dabs a little of the sea colour into the white shapes.*

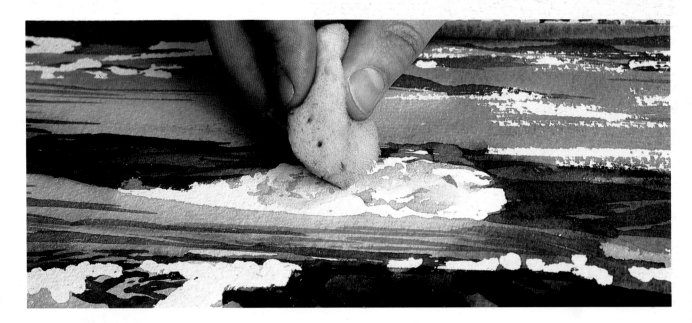

◁8 *Froth is spattered with white gouache, flicked with a toothbrush while the rest of the painting is masked with a sheet of paper.*

▽9 *The final picture is a lively representation of a rough sea, painted in a limited range of colours and in the minimum of stages.*

95

INDEX